QUARANTOO[NS]

CARTOONS FROM A NEW NO[RMAL]

COVID MARSHALL

JAMES MELLOR

Published by
Filament Publishing Ltd
16 Croydon Road, Beddington, Croydon,
Surrey CR0 4PA
+44 (0) 20 8688 2598
www.filamentpublishing.com

Quarantoons - Cartoons from a new normal
by James Mellor

ISBN 978-1-913623-79-1

What people are saying about James Mellor's cartoon books

I love this book; bringing history to life through cartoons is genius.
Gregg Wallace - Host of BBC's Time Commanders and Masterchef

A Great book that will have you laughing out loud as you browse dozens of splendidly witty cartoons.
This England Magazine

It takes a rare talent to be able to make some sense of a subject as fraught and divisive as Brexit let alone be able to draw insightful, witty and thought provoking cartoons on the subject.
Lee Robertson BA FRSA Chartered FCSI

Acknowledgements

Many of the cartoons in this book are being published for the first time. Many others have had a previous home elsewhere. I would therefore like to thank all those who published, exhibited, or commissioned the cartoons that feature here. My thanks to Private Eye Magazine, The Northants Telegraph, Dare Create Succeed, OVL Magazine, BedsLife Magazine, The Briars Group, Octomembers Group, Go NorthWest, The Herne Bay Cartoon Festival, and The Shrewsbury International Cartoon Festival.

Thank you to Dame Ruth Carnall for your insightful foreword.

Thank you to my fellow members of The Professional Cartoonists' Organisation and the Cartoonists' Club of Great Britain. The support of peers is priceless in such an opaque, mysterious business. Thank you for the advice, guidance, and support.

My thanks also go to The Company of Entrepreneurs in the City of London for not only allowing me to engage in my passion for history, but for the connections made and opportunities presented.

Thank you to my family who have encouraged me to draw since childhood and continue to do so today.

My sincerest thanks, as ever, go to Rachel. A loving, supportive wife and a scrupulous cartoon editor. Thank you for everything you do.

Thank you to Talitha for your infectious energy and to Elias for your infectious grin. You are both amazing.

Thanks to Hera the cat for keeping my studio chair warm.

About the Author

James Mellor is a freelance cartoonist based in the UK. He is a regular contributor to Private Eye Magazine and has been published in The Sunday Telegraph, The Northants Telegraph and numerous other publications. He has also provided cartoon illustrations for a wide variety of books. He is a member of the Professional Cartoonists Organisation and the Cartoonists' Club of Great Britain.

To put cartoons to use in the corporate world, James launched James Mellor Creative in 2012. In this capacity, he has provided words and pictures in newsletters, conferences, websites, blogs, and social media posts for large multinationals, individuals just starting up, and many businesses in between.

A History graduate from the University of York, James is the author/illustrator of *Drawn From History: A cartoon journey through Britain's past*, *Brexit: A Drawn-Out Process* and is the Honorary Historian to The Company of Entrepreneurs in the City of London.

James lives in Felmersham with his wife Rachel, daughter Talitha, son Elias, four unremarkable chickens, and a small, sociopathic cat.

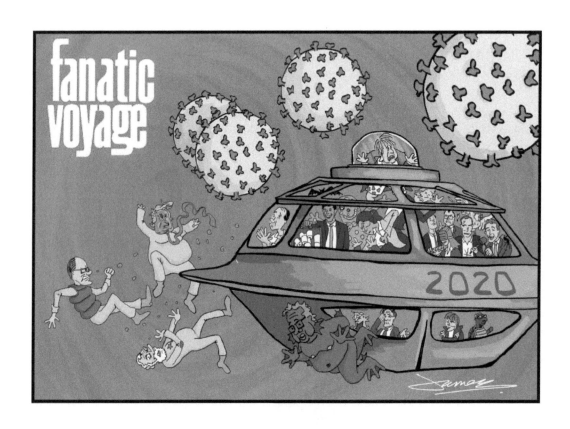

Foreword

As I write this introduction, I hover between hoping and praying that the pandemic is largely "over" and staring obsessively at the number of cases in the UK rising each day which tell me that we are heading right back into it. Each of us is trying to make sense of the experience of the last nearly two years. No one has been unaffected. My context is that of working in the NHS for over 40 years and so I see this through the eyes of current and former colleagues struggling to deal the immediate impact of Covid and now the aftermath of huge waiting lists. None of this feels normal... It feels unprecedented and yet we are beset by politicians, scientists and commentators expressing their views about what the "new normal "means.

James has produced this book of cartoons with the aim of amusing, informing, and challenging us whilst helping us to reflect on these unprecedented times. These are the aims of all good cartoonists. The book looks at the history of the pandemic through its separate chapters from the gathering storm via the old normal, lockdown, unlocked, holidays, vaccination and finally to the new normal.

James is right to make the claims he does about the value of humour but even more so the value of cartoons to serious journalism. In my world of the NHS a rather dark humour can be essential to surviving the daily reality.

Each reader will be drawn to the cartoons which illuminate their own experience, and which have resonance for them. I liked the drawing of the rat exclaiming "trace my contacts! I live with 1274 siblings", the depiction of contact tracing being done by physically tracing the outline of a man lying down and the hilarious drawing of the "UK variant". These and several others reminded me of some of the highest profile, stressful and controversial issues faced by friends and colleagues working in healthcare.

I hope each reader will find cartoons which have meaning for them but most of all I hope that the book succeeds in its aim of amusing, informing, and challenging you and helping you to reflect on your own journey towards a "new normal". Whatever that is!

Dame Ruth Carnall DBE

Former CEO of NHS London, Founder of Carnall Farrar

Contents

For Betty

1927 - 2020

Introduction

There is nothing very normal about the 'New Normal'. If you ask me, there was nothing particularly normal about the 'Old Normal' either. Nothing has felt particularly normal for several years now. As someone whose job is to exaggerate, parody, and satirise the news it has become clear to me that the real world has become increasingly bizarre before any cartoonist has even set to work.

I remember people's disillusionment during the 2015 General Election when forced to choose between David Cameron, Nick Clegg and Ed Miliband's parties. Dull, interchangeable men in dark grey suits. In the past few years all manner of bizarre living cartoons have roamed the news landscape: Boris Johnson, Dominic Cummings, Jeremy Corbyn, Nigel Farage and Donald Trump, to name an obvious few.

How to exaggerate and ridicule the already exaggerated and ridiculous? How to make already surreal news stories into successful cartoons? It has been a challenge. However, though the world had become very strange, the coronavirus pandemic has made it far more so. At the risk of sounding like the opening to Wells' War of the Worlds, no one would have believed in the last months of 2019 that within weeks we would be forbidden from seeing our loved ones and confined to our houses except for a daily period of state-sanctioned exercise.

During the lockdowns of 2020 and 2021, cartoons have proved their worth on several fronts. Firstly, in terms of morale. Many people have been scared, angry, grieving, bored, depressed and, of course, ill. Covid aside, any mental health problems that existed before the pandemic were only exacerbated by isolation. Cartoons aren't going to solve any of the great societal issues of our time, but humour can help people get through another day. As the late Stan Lee put it, "entertainment is one of the most important things in people's lives. Without it they might go off the deep end. I feel that if you're able to entertain people, you're doing a good thing."

Secondly, cartoons (as silly as they can be) have proudly flown the flag for serious journalism. I am aware that cartoonists require a platform to reach our audience and am in danger of becoming the scorpion stinging the frog carrying him across the river in the fable, but the media have not come out of this pandemic very well. From scaremongering and hysteria on one hand to acquiescence and pandering to the government on the other, the news broadcasts have not filled me with confidence. However, cartoonists have (in my humble opinion) trodden a more dignified path, skewering what needed to be skewered along the way.

Thirdly, cartoons have helped us practically deal with a changing world. I was proud to have produced a series of cartoons (some of which are included in this book) introducing new health and safety measures to public transport. As ever, cartoons can convey ideas quickly, simply, and memorably. I was pleased to provide cartoons for a successful commercial pitch to manufacture vaccines in the UK. Cartoons catch the eye and make an impression.

I'd like to think all three strands are represented here, though I hope the cartoons in this book sit primarily in the first category. I hope you are entertained. This is a book about how the UK and the world have changed. A global pandemic isn't a laughing matter, but the way in which our day to day lives have been upended is indeed funny. This is a book for those exhausted by zoom meetings, confused by ever changing covid guidance, or exasperated by overnight virology 'experts' (who I'm certain were only on the news panel just last month as supposed Brexit 'experts').

This is our journey into the new normal. It's not very normal. Perhaps it never was.

I hope you enjoy the cartoons.

James.

@jamesdfmellor

The Gathering Storm

"The plague, it seems, grows more and more at Amsterdam; and we are going upon making of all ships coming from thence and Hambrough, or any other infected places, to perform their Quarantine (for thirty days as Sir Rd. Browne expressed it in the order of the Council, contrary to the import of the word, though in the general acceptation it signifies now the thing, not the time spent in doing it) in Holehaven, a thing never done by us before."
— Samuel Pepys, The Diary Of Samuel Pepys

It was a strange feeling to watch a disaster coming from afar. Like a tidal wave in slow motion, inexorably moving closer. In the UK we saw the news from China, then from New York, then Italy. In today's globally connected world, the English Channel was no defensive moat. We watched as the virus spread closer and there was nothing any of us could do. Well, we could go and buy large amounts of toilet roll, but there was nothing we could *usefully* do.

I say nothing we could do; being British, we did what we always do. We made jokes, we made fun, and we carried on. Except for the oddballs buying the toilet roll, of course. Cartoonists who make fun of the news continued to make fun of the news. Laughter is a coping mechanism that helps confront adversity and dampen anxiety. It was very important to carry on cartooning. As many a redcoat joked down the centuries, 'for what we are about to receive...'

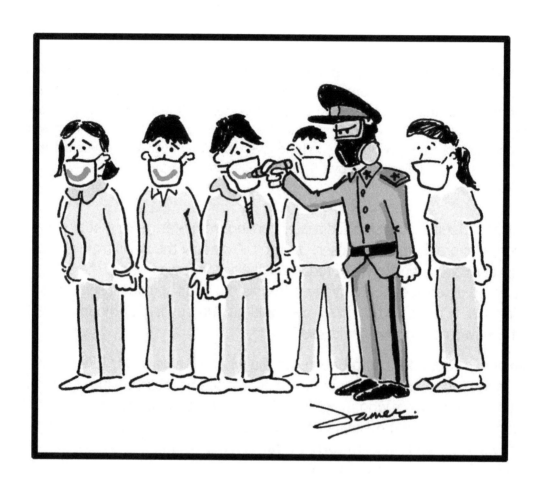

First published in Private Eye Magazine no.1516

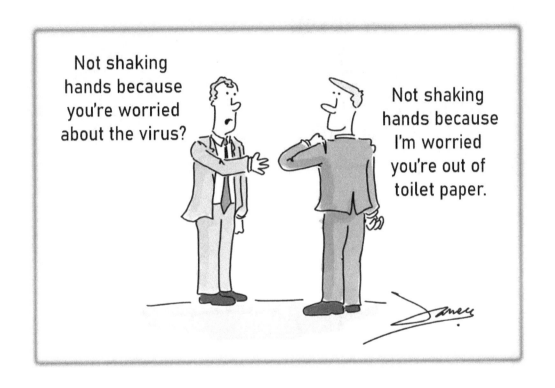

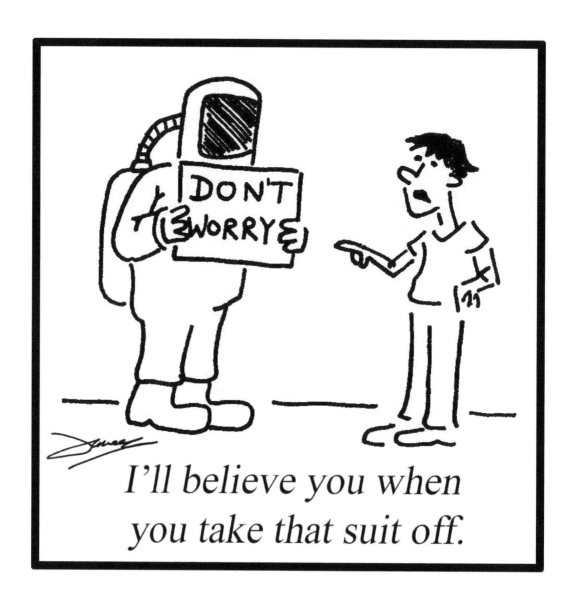

I'll believe you when
you take that suit off.

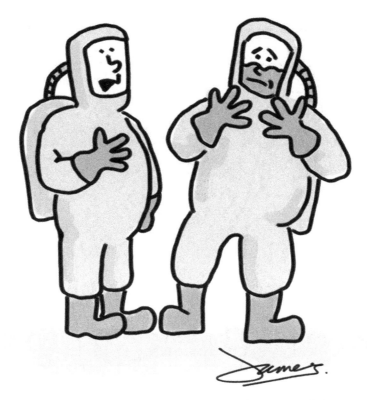

Usually we go to the toilet <u>before</u> putting the suit on.

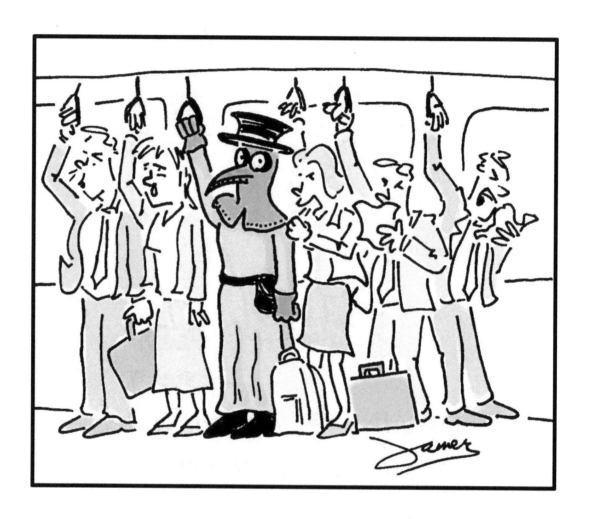

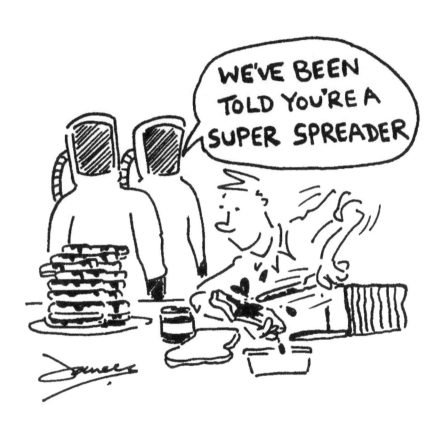

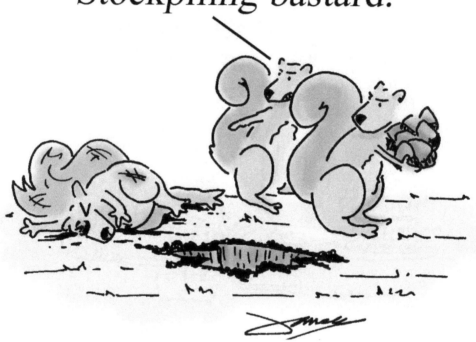

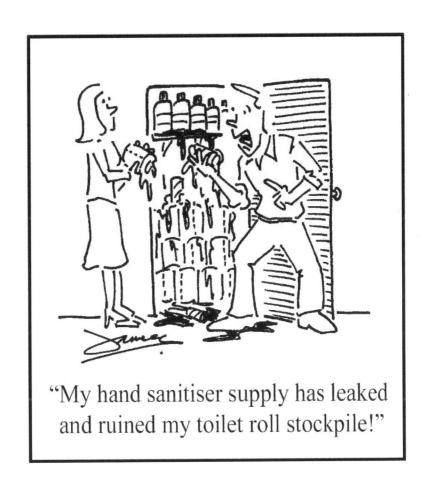

"My hand sanitiser supply has leaked and ruined my toilet roll stockpile!"

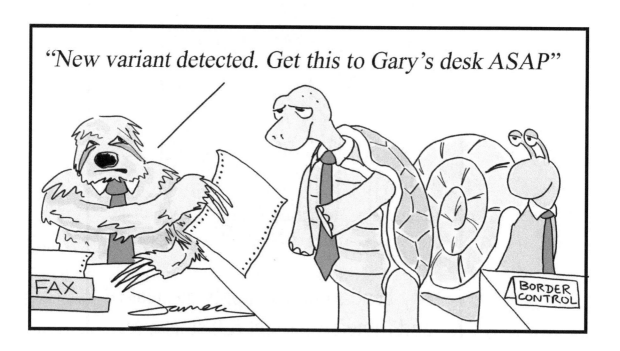

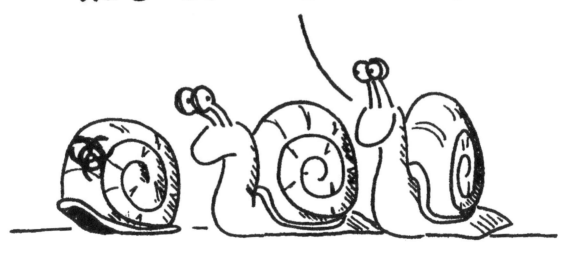

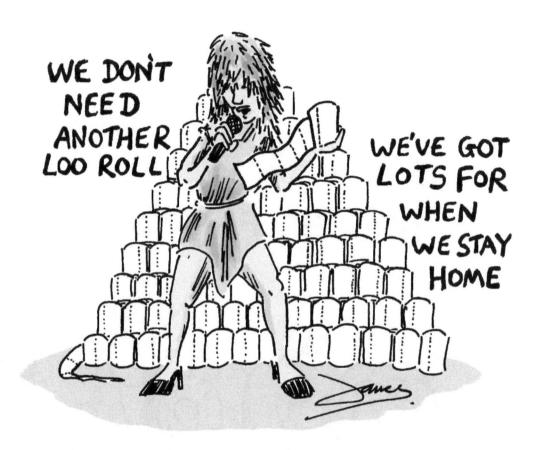

Quarantina Turner

First published in Private Eye Magazine no.1519

The Old Normal

Though the UK was watching and waiting for COVID-19 to arrive on these shores, life still went on. And life was busy. A decisive general election had just ended years of Brexit stalemate and the UK was out of the EU. Having previously drawn and written an entire book on Brexit, I thought it would be a bit much to go down that road again here.

However, there were plenty of other things to hold our attention. Some relatively normal things, others less so. VR headsets for cows, proposed defence cuts, simmering tensions in the Middle East over Iran (as ever), and CEOs escaping Japan hidden in cello cases were some of the stories that marked the dawn of 2019.

Please enjoy a brief look back to a simpler, more normal(?) time.

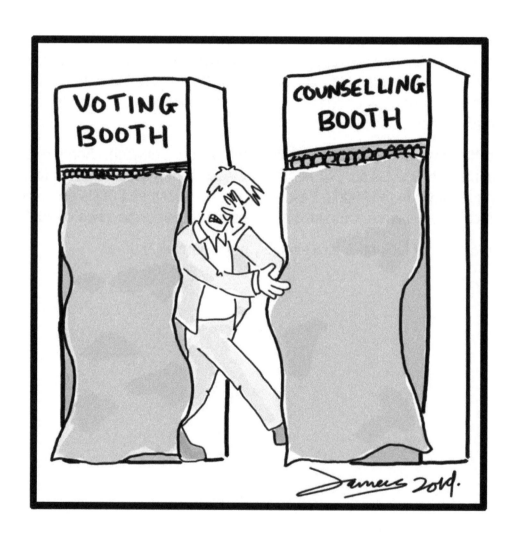

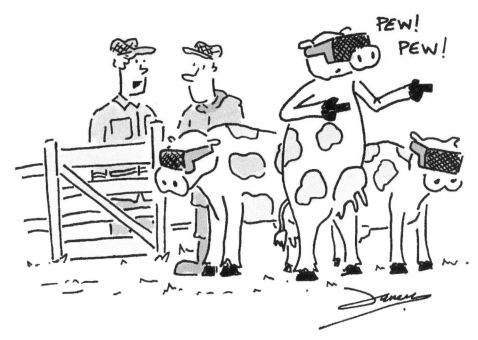

Most are set to 'Virtual Field',
but this one's stuck on 'Call of Duty'.

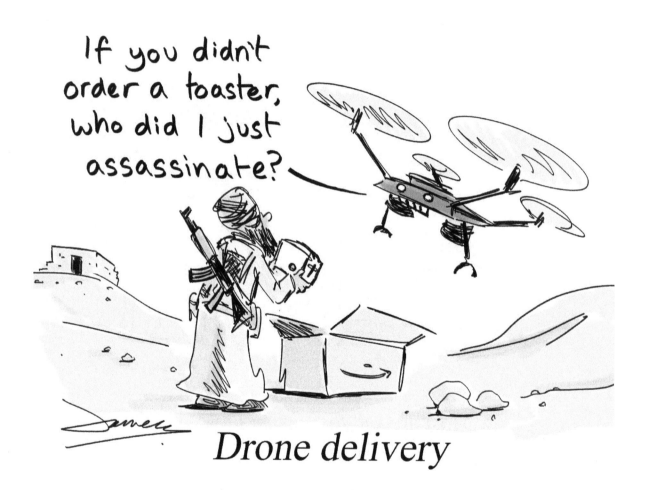

Drone delivery

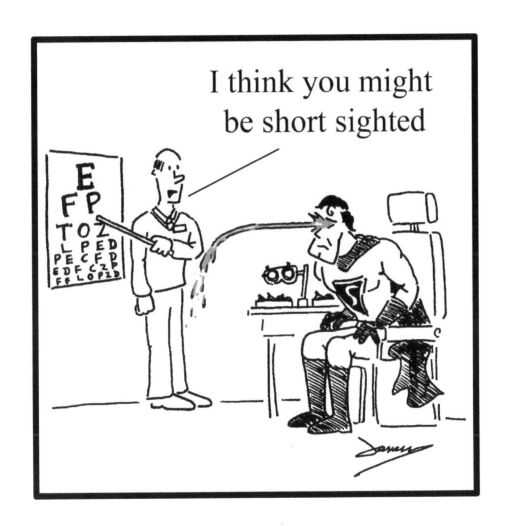

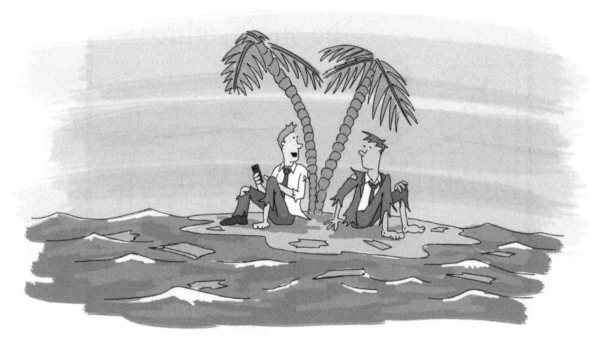

"Are you on LinkedIn?"

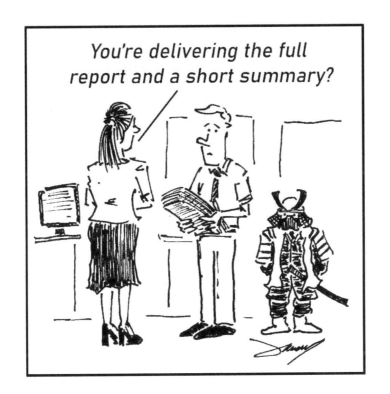

31

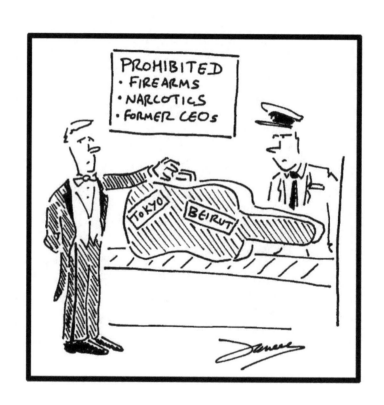

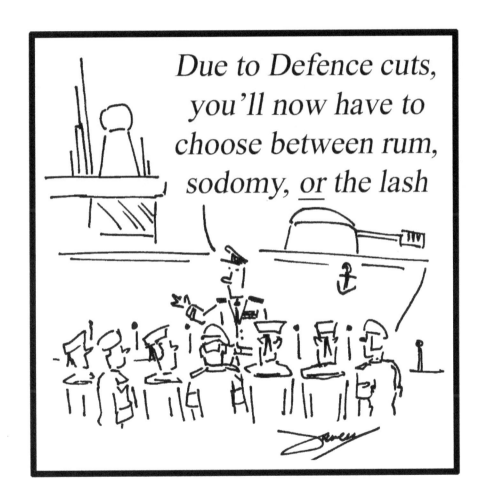

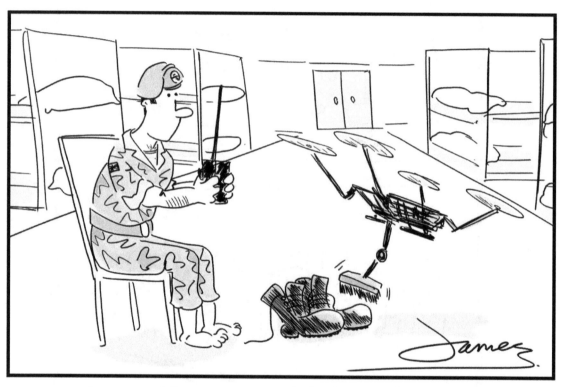

A smaller, more high-tech army.

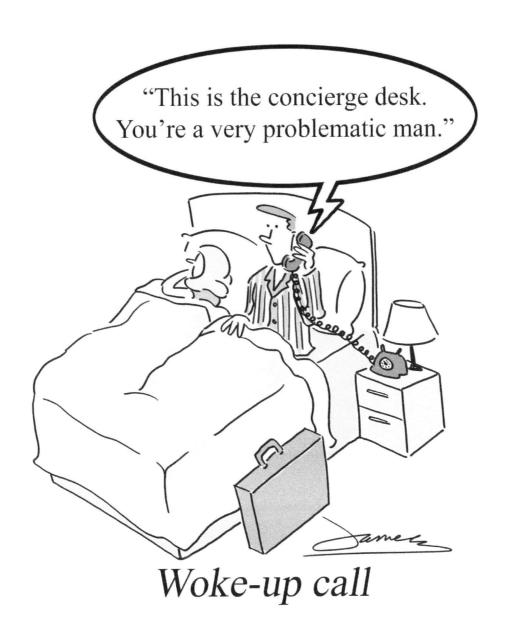

Woke-up call

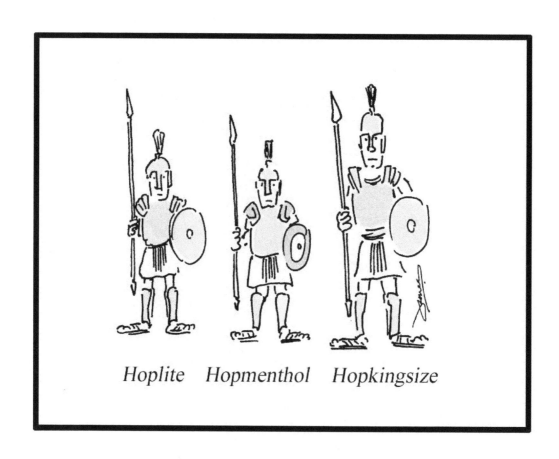

Hoplite *Hopmenthol* *Hopkingsize*

Lockdown

And then we were indoors. For a while. The three-week lockdown to 'flatten the curve' turned into something slightly longer and was then repeated. And repeated. For all I know, you may be currently reading this from lockdown again.

What do the British do when isolated in their homes? Well, cartoonists carry on as normal as this is just how we live. As for the rest of society? From what I gather, they bake soda bread, watch box sets, pretend to do the TV aerobics, then go on social media to lie to online friends about how they've learnt another language and written a screenplay.

In fact people actually got up to some pretty amazing things: helping out their community, making PPE, raising money for charity, delivering medicines, and all manner of other good works. That sort of laudable behaviour doesn't make for good cartoons though.

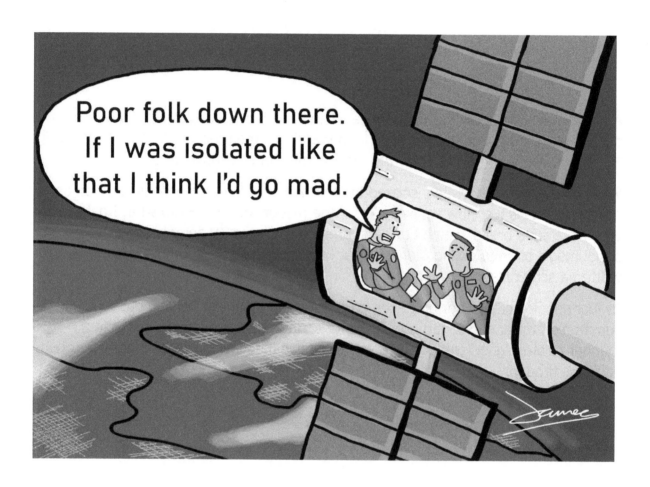

Are you alright? You seem distant.

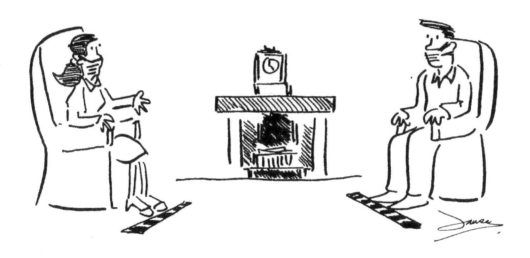

But we've only just reopened the economy after the lice

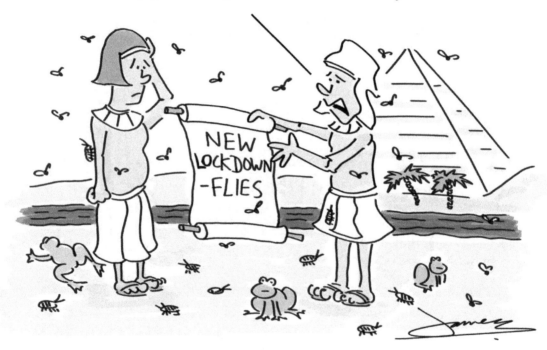

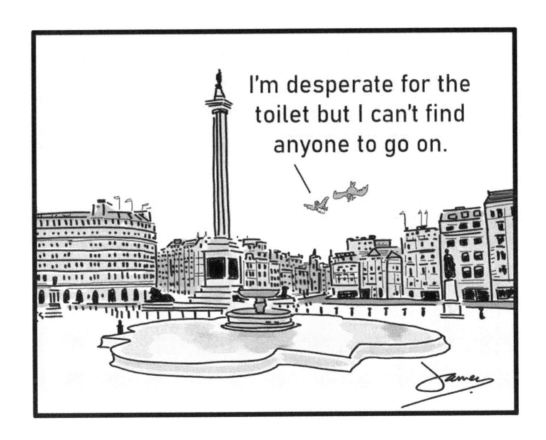

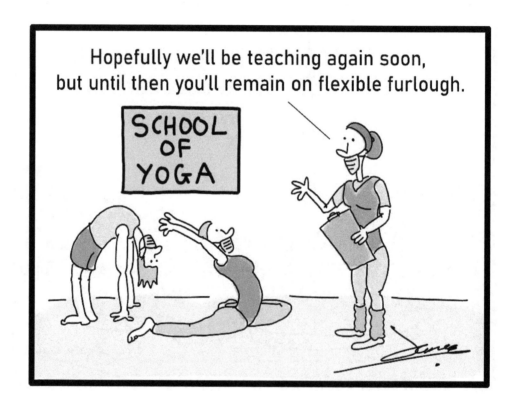

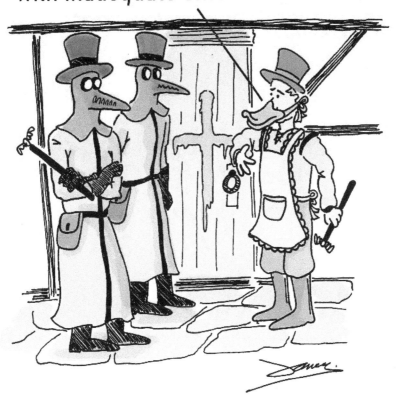

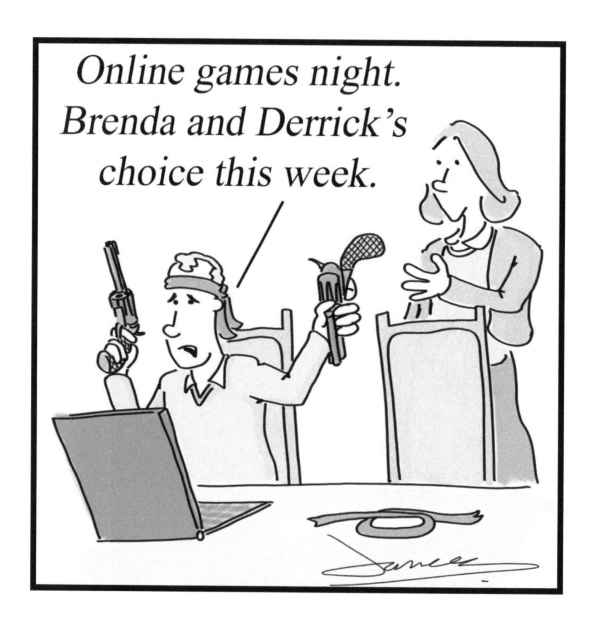

You didn't notice the "I"?

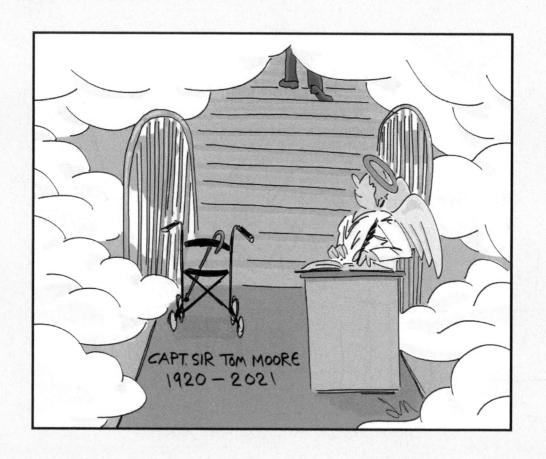

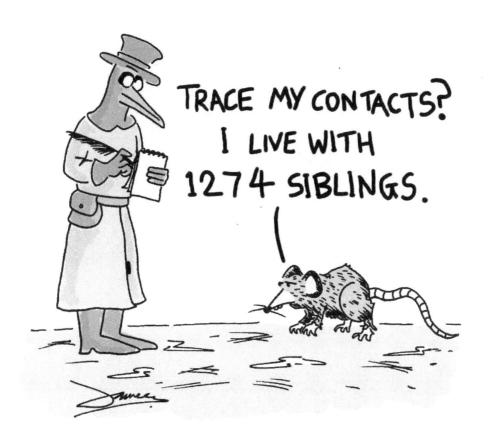

First published in Private Eye Magazine no.1524

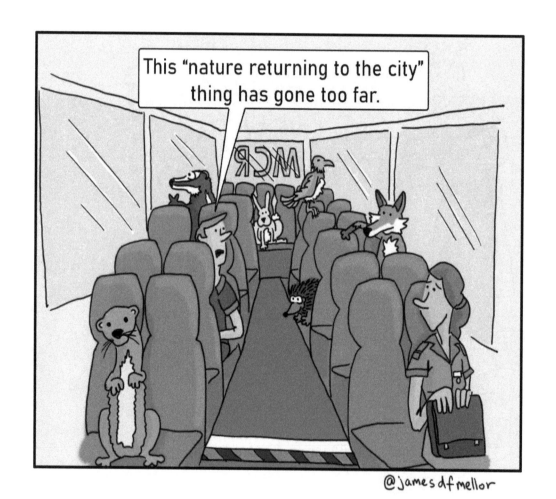

@jamesdfmellor

Unlocked

With multiple lockdowns came multiple unlockings. As with the previous chapter, I've included cartoons from all of the respective 'opening up' phases together. Just as individuals reacted differently to being confined to their homes, the responses were varied when the time came to re-emerge. Some grasped their returned freedoms with both hands whilst others, in many cases understandably, took more cautious steps into the world. Most were, for some reason, more keen to embrace the freedom of visiting the pub than returning to the office.

With freedom and mingling came increased transmission and, ultimately, new variants of the virus. This was where the hamster wheel Groundhog Day experience began. Into lockdown, out of lockdown, back into lockdown again. New measures had to be adapted to, new precautions had to be taken. Each time we were allowed back out into society, the strangeness of the new world became a bit less strange. Whether it ever felt 'normal' is up for debate.

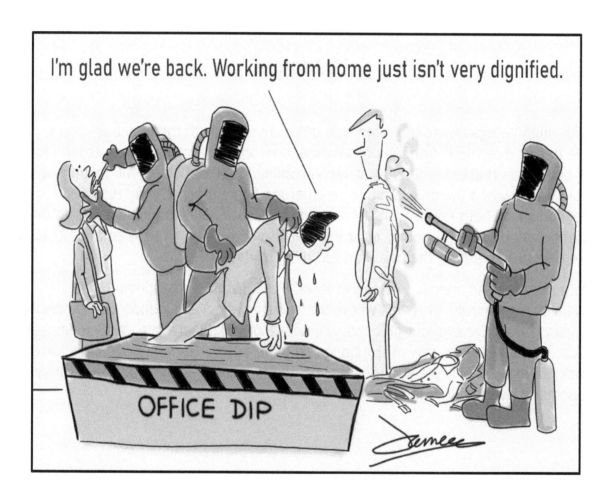

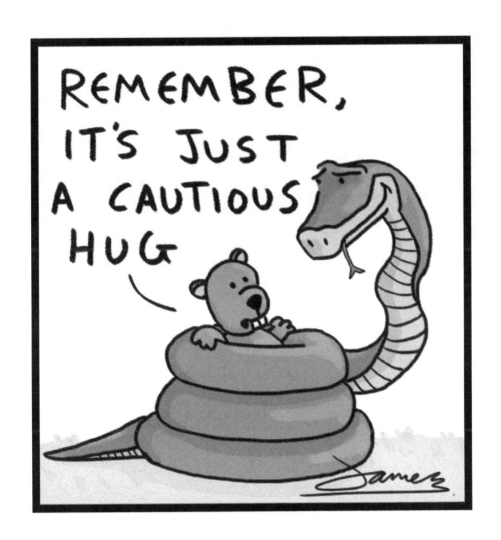

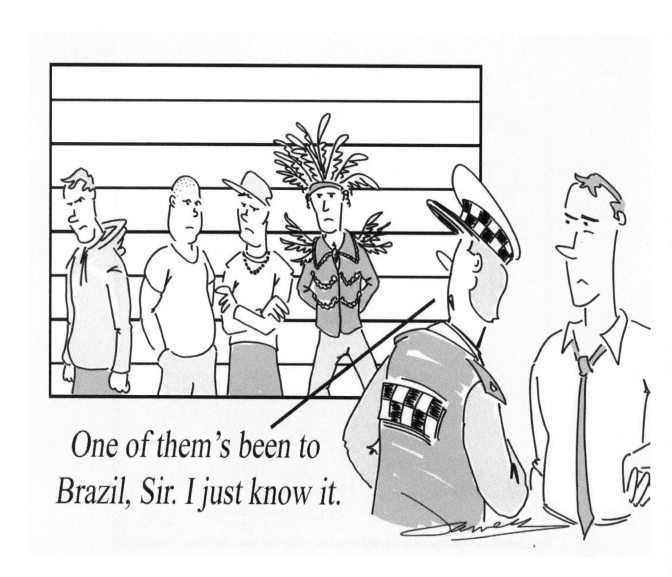

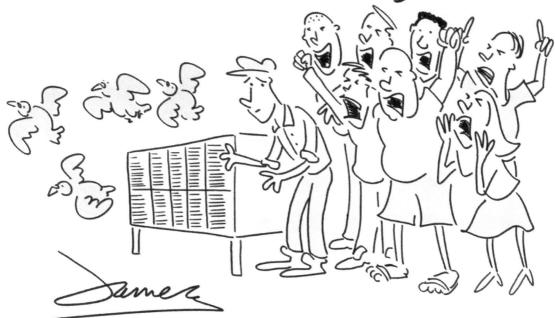

Pigeon racing crowds return

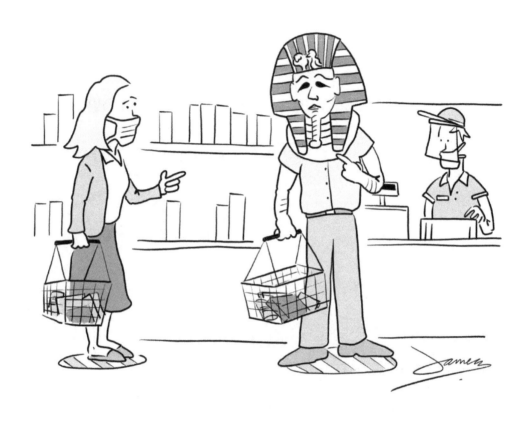

"Yes, it is reusable - it works
in this life and the next"

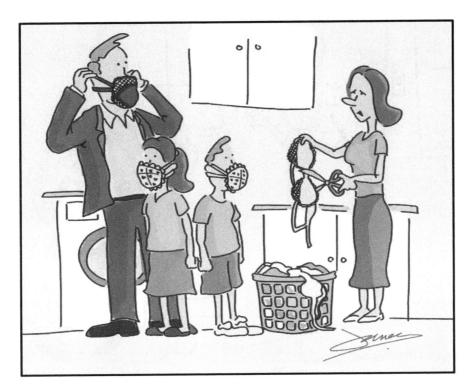

"The sacrifices I make for this family..."

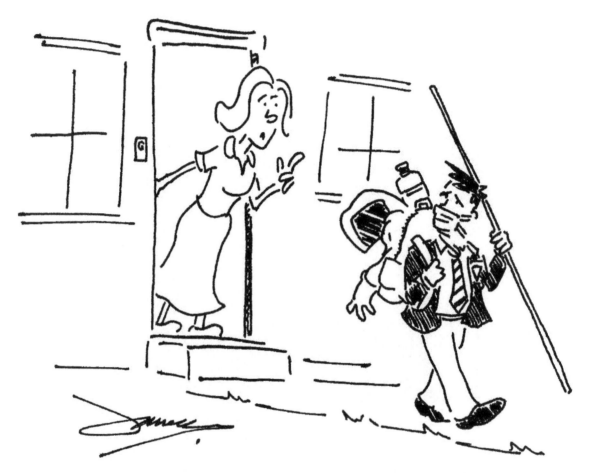

Do you have your lunch, PE kit, mask, NBC kit, Hydroxychlorioquine, two metre distance stick...

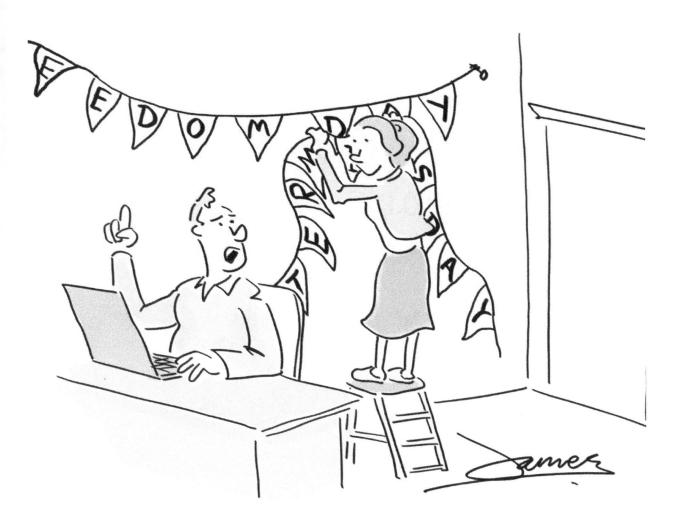

It's bad luck to still have your Freedom Day decorations up by Terminus Day

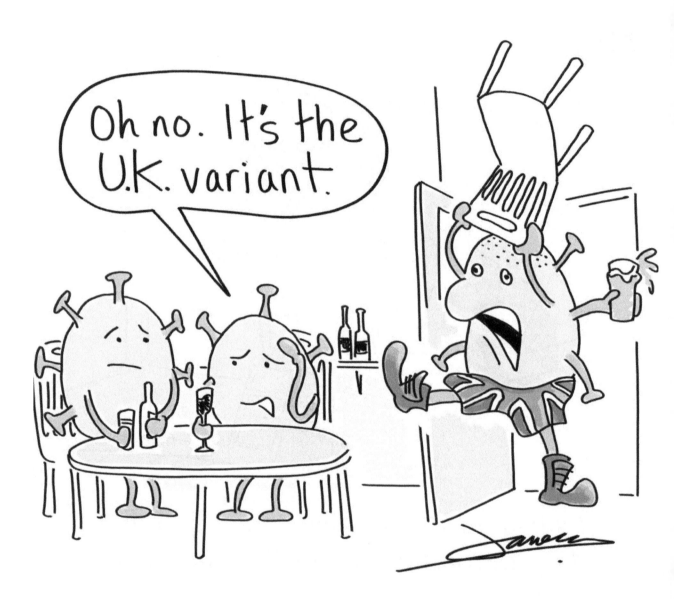

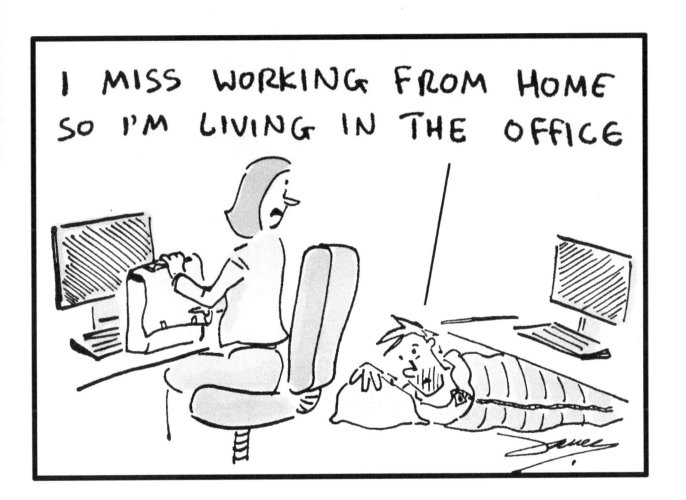

"It's all on my social media feed, Miss."

Business As Usual

It is important to remember that though life was utterly transformed during the past two years, it didn't stand still. The world continued to turn. Key workers continued to carry out their roles much the same as before. Cartoonists continued to work alone in their caves not noticing the difference. Politics, sport, and trade all had to continue, albeit in new ways.

As the plague months rolled by an Olympic Games took place, as did the European football finals. A container ship clogged the Suez Canal and a rover parachuted onto Mars. A new US President was elected, the current UK Prime Minister got married, and a former UK PM crept back into the news. Life went on for cartoonists too and I was pleased to take part in trialling an art recognition algorithm by creating a topical version of a classic Gillray cartoon. A cartoon that's included here because I couldn't work out where else it might fit.

"He's part of that European super league"

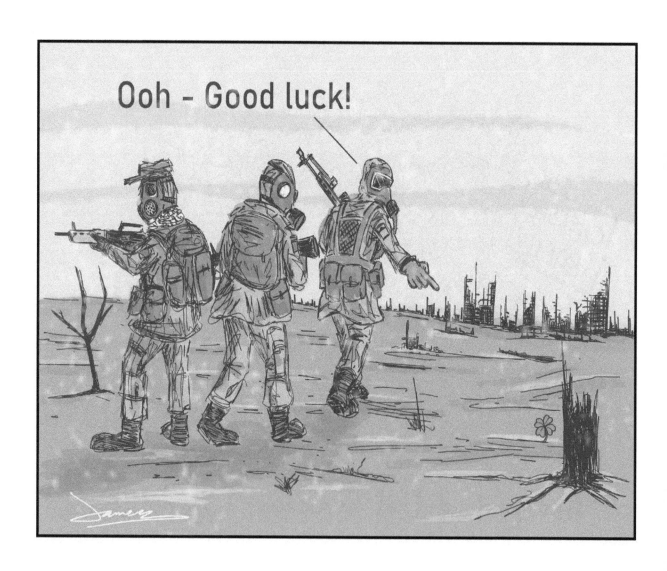

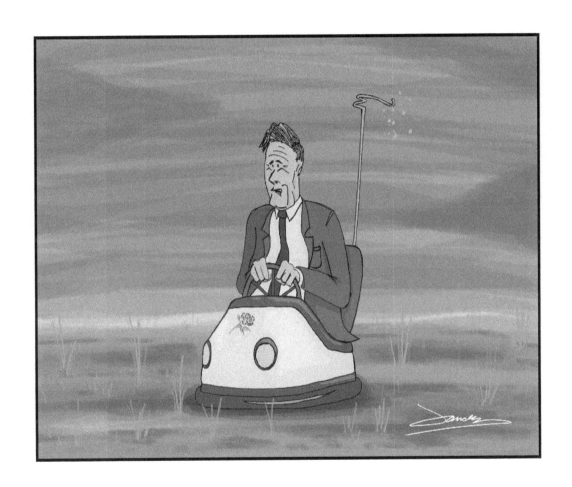

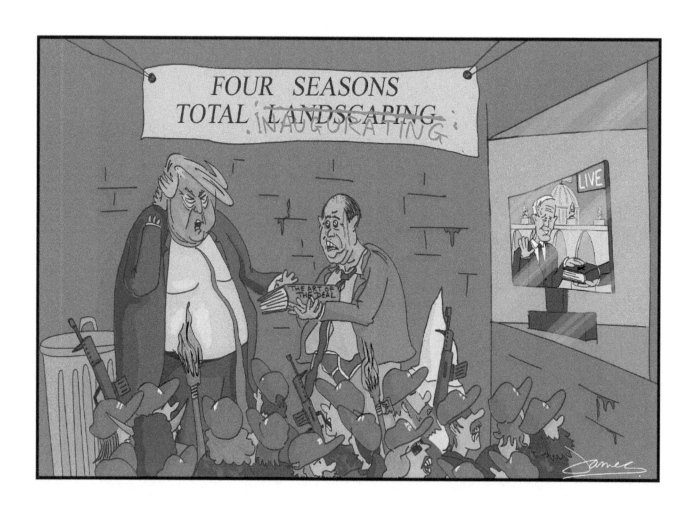

66

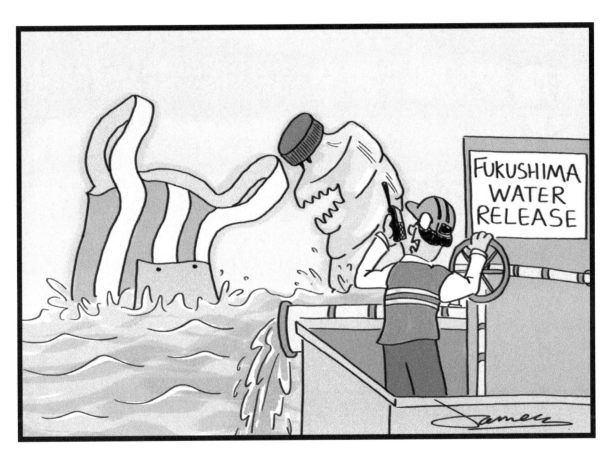

"No. There's no giant lizard".

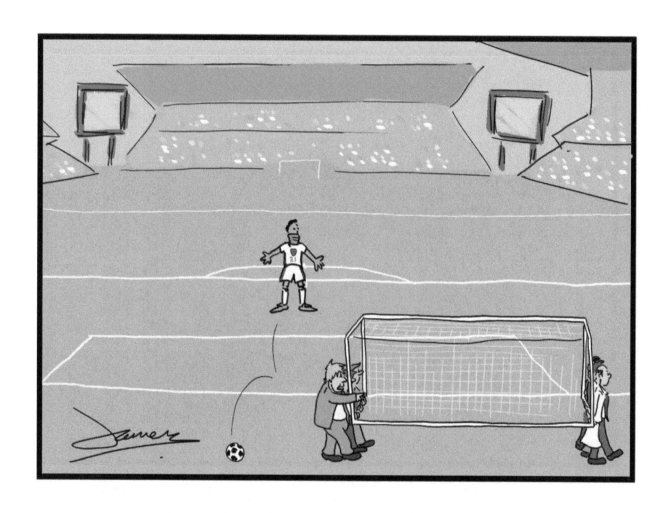

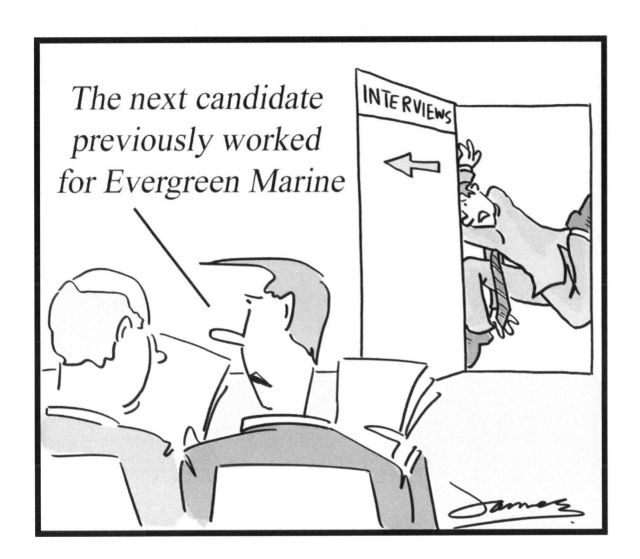

"Experts say that symptoms can persist long after the initial period in public office"

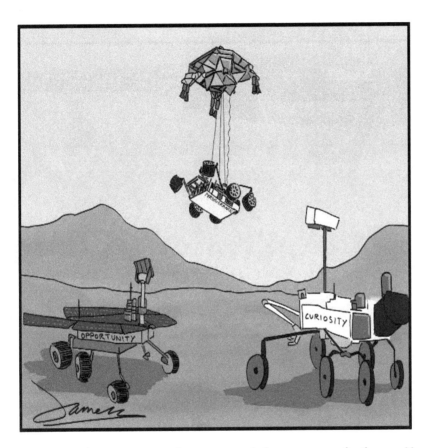

"Coming over here, taking our jobs..."

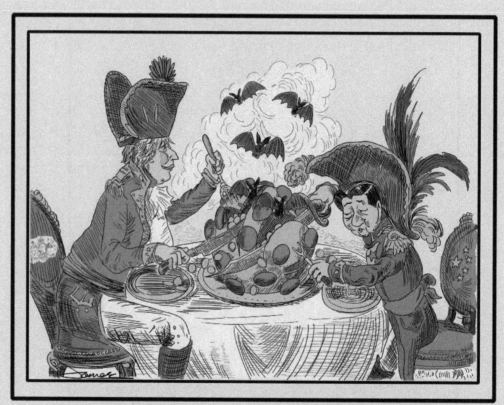

The Plumb-pudding infected

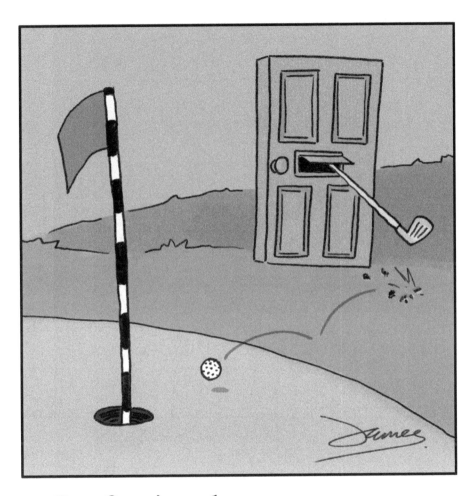

*Professional sport to resume
behind closed doors.*

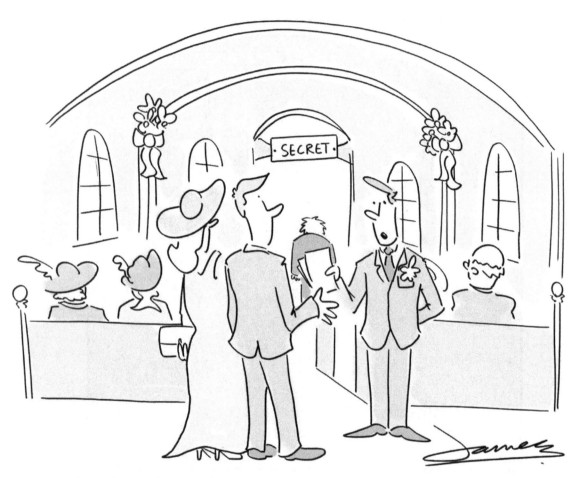

"The bride's donors are seated to the left,
the groom's benefactors to the right"

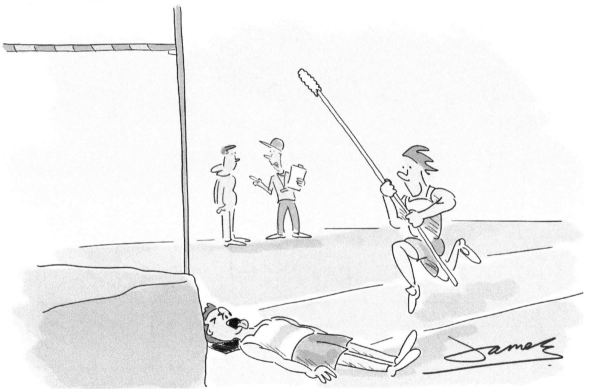

"We train and test at the same time"

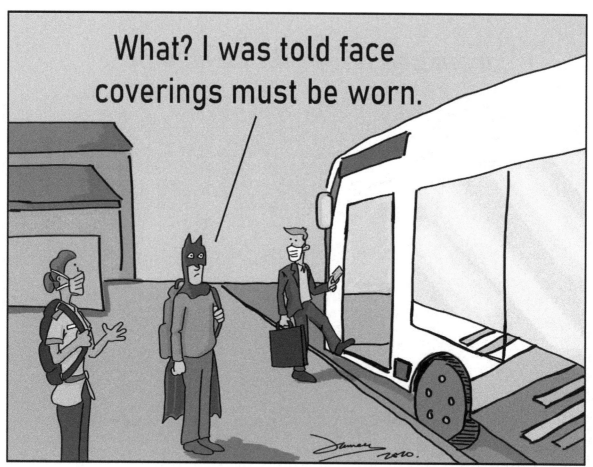

Rules and Regulations

The new normal runs by new rules. Once there was a time when I think I understood them. We all knew where we were with the rules when life first opened up: Up to two households could meet outside at a two-metre distance for a set duration of time, as long as one member of the party was constantly in motion and had collected the correct paperwork from the planning department's filing cabinet marked 'beware of the leopard'. Then things became complicated.

Obviously, all of these regulations were introduced with the best of intentions, but that doesn't stop us griping about them. We are British after all. Without traffic lights, city centres would be chaos, travel would be a dangerous free-for-all, and cars would plough into roadworks, but that doesn't stop us moaning about being stuck behind a red light.

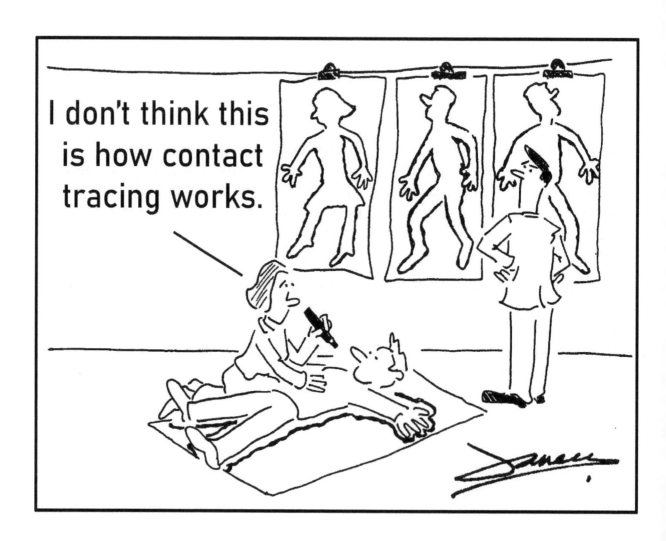

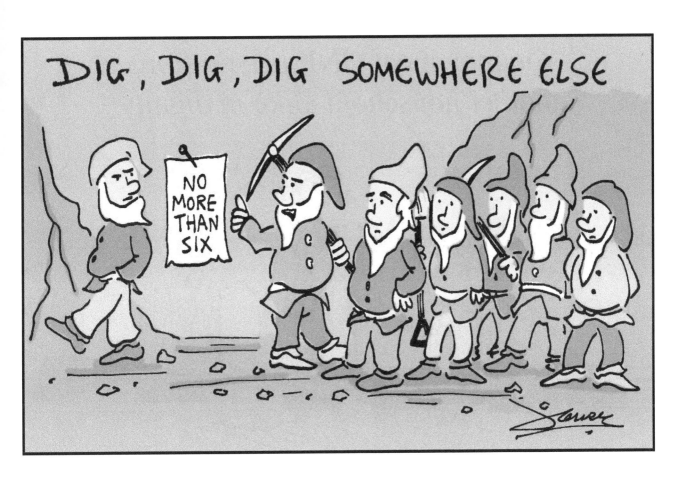

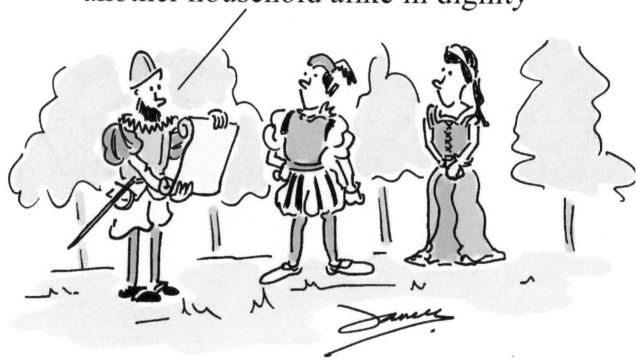

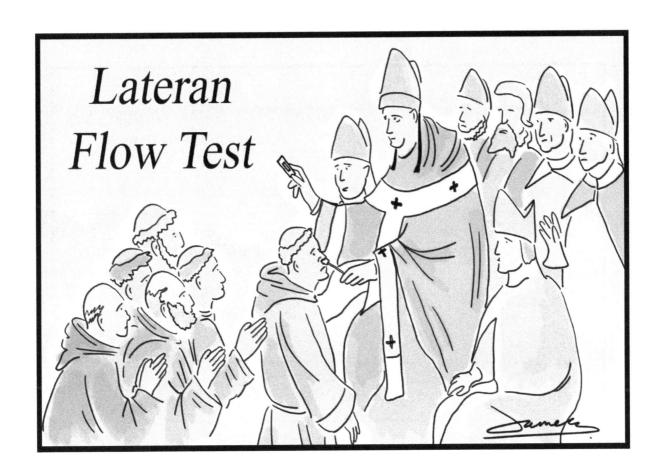

81

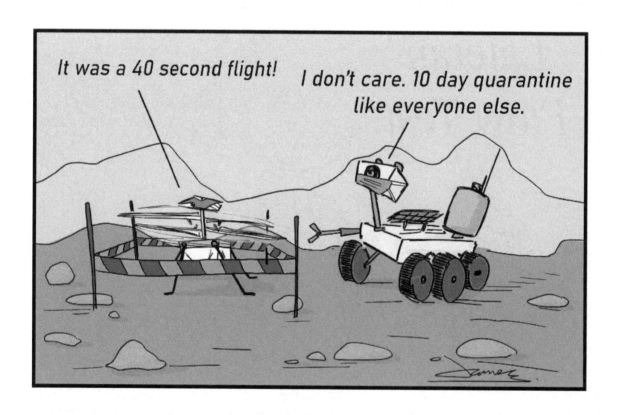

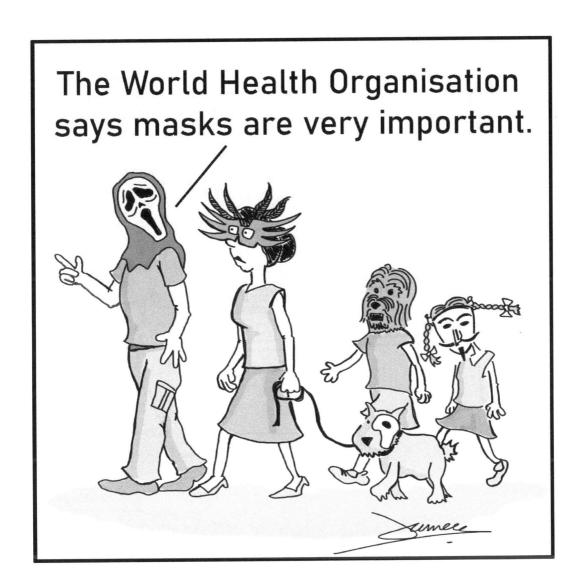

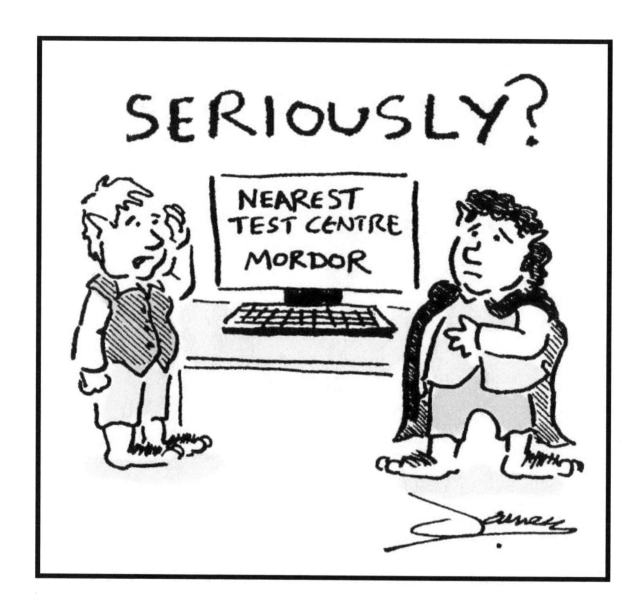

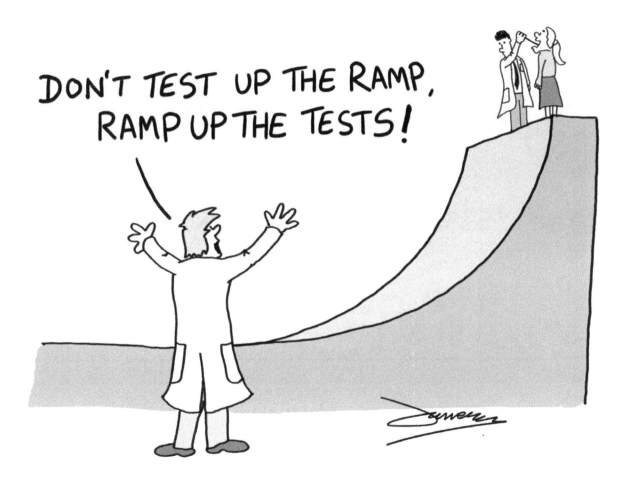

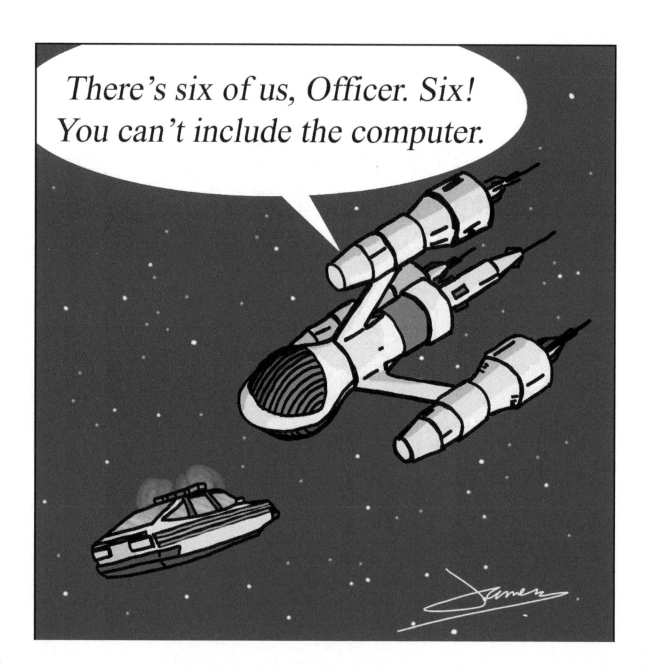

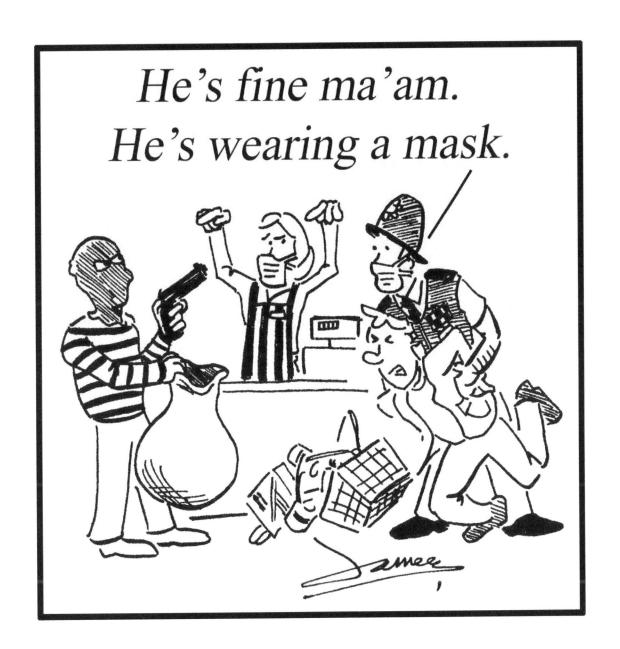

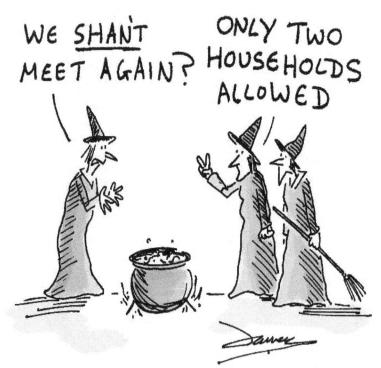

Double, double toil and trouble;
Limited space in a social bubble.

Holidays

I should use this page to tell you about the next chapter. Explain how it features our trips at home and away, and how we adapted the main UK holiday seasons of Christmas, Easter and Summer to comply with the requirements of the new normal with entertaining consequences.

Instead, I would like to take the time to point out that a 'staycation' is taking time for a holiday but remaining at your place of residence in your home city, town or village. Perhaps you'll enjoy your own garden, do some DIY or visit the sights on your doorstep you never normally think of going to. Travelling somewhere else in the UK is not a 'staycation', it is a UK holiday. I shouldn't have to point out this distinction but people keep getting it wrong and it's been bothering me all plague long.

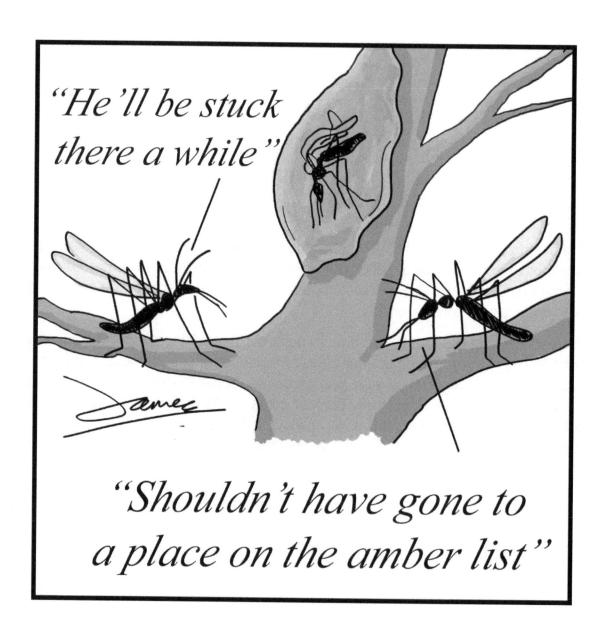

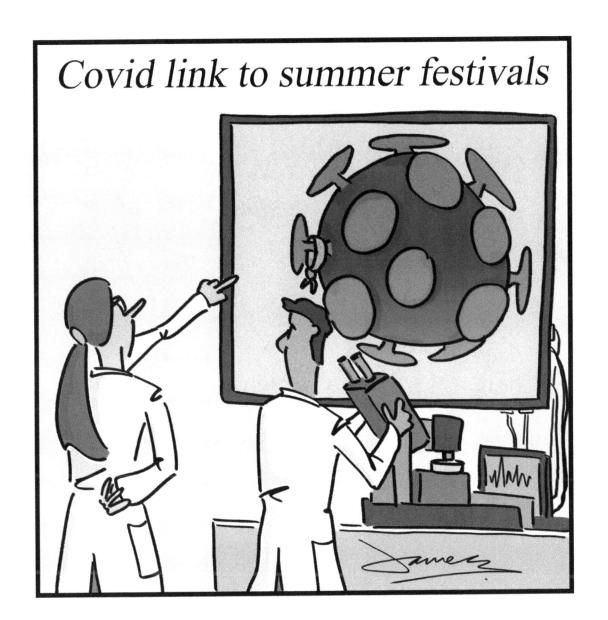

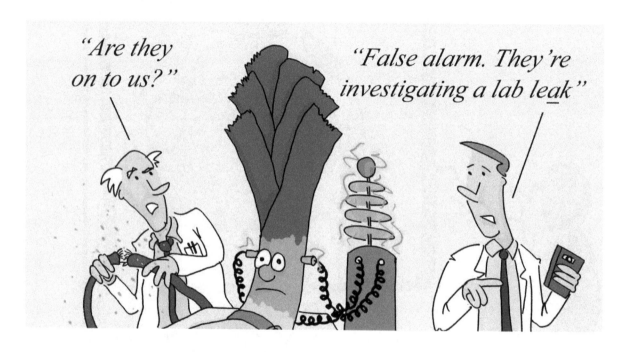

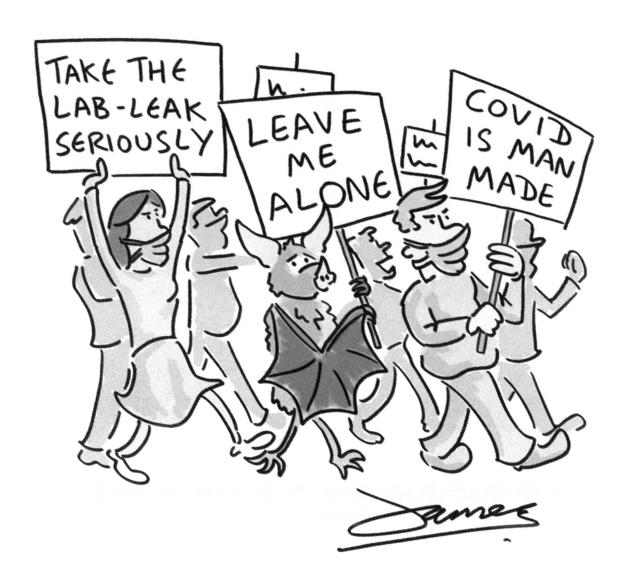

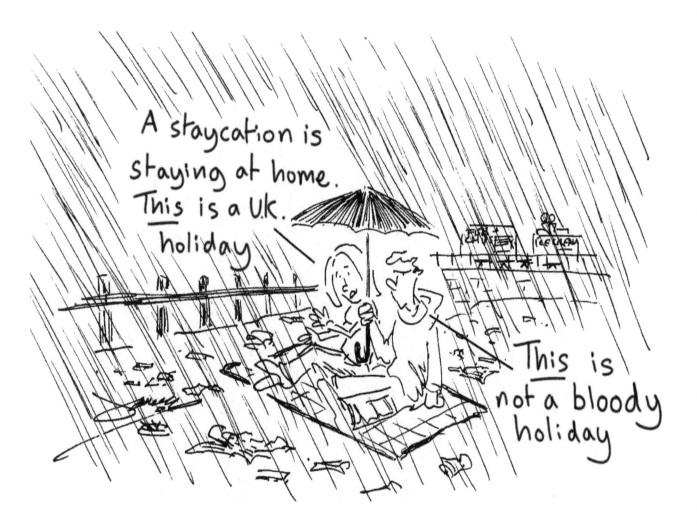

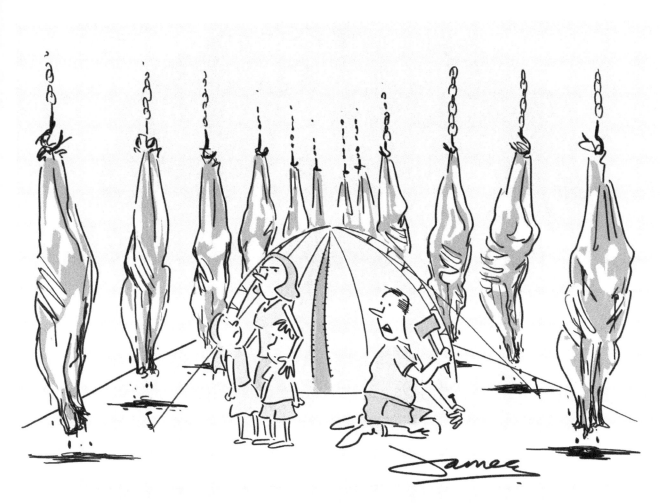

"I thought you wanted a steakation?"

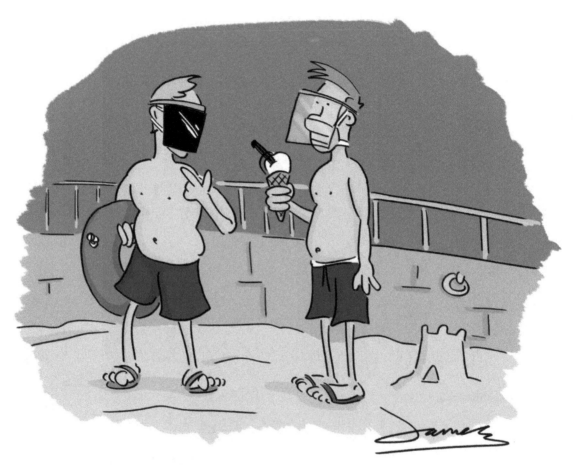

"I've switched to my transition visor"

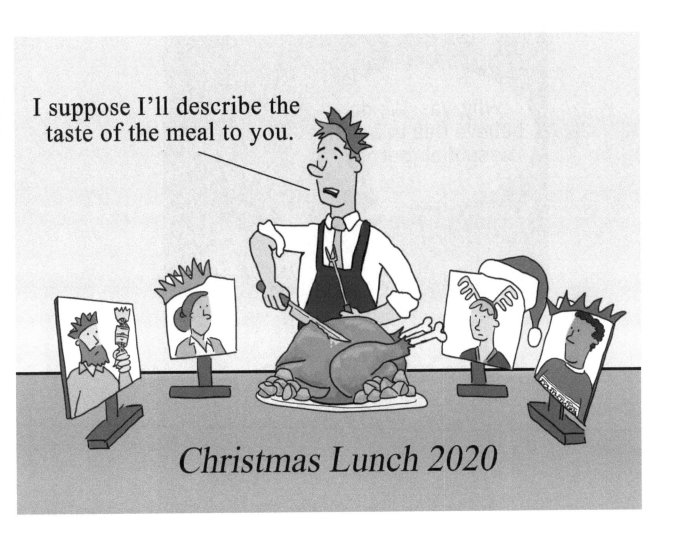

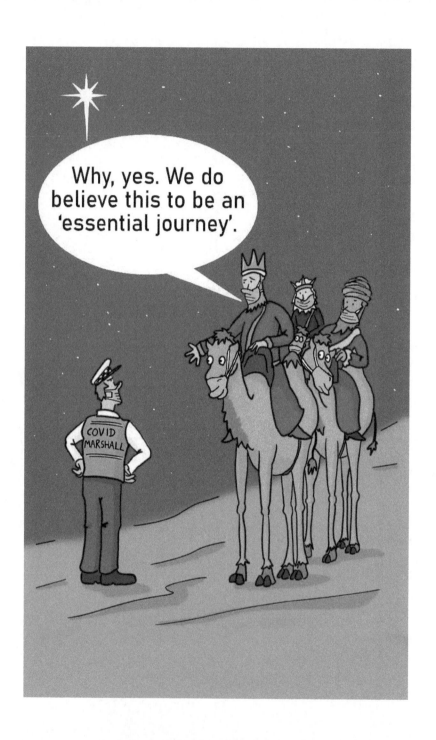

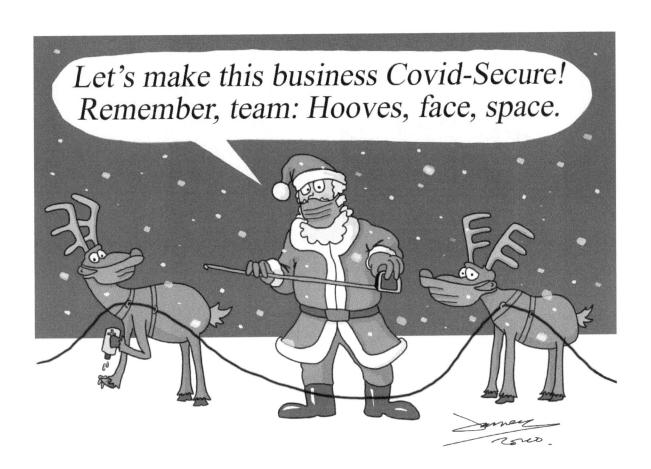

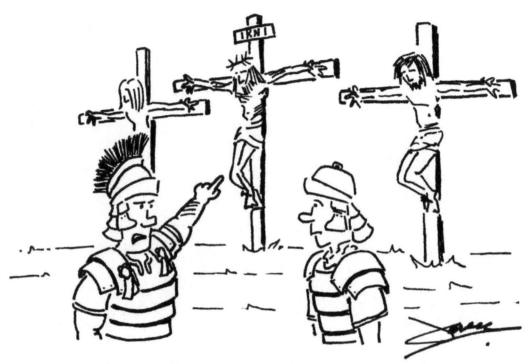

"I said TWO METRES between them
- remember social distancing!"

Odds and Ends Drawer

Partly a designated break to give you the reader a change from pandemic related cartoons. Partly an opportunity for me to present some of my favourite cartoons of the past couple of years that didn't really fit anywhere else.

Not related to any event or inspired by any news story, these cartoons are merely a horrible glimpse into my mind.

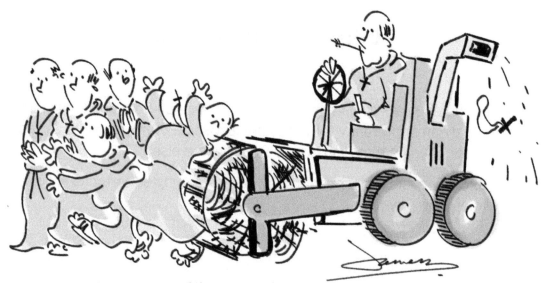

Compline Harvester

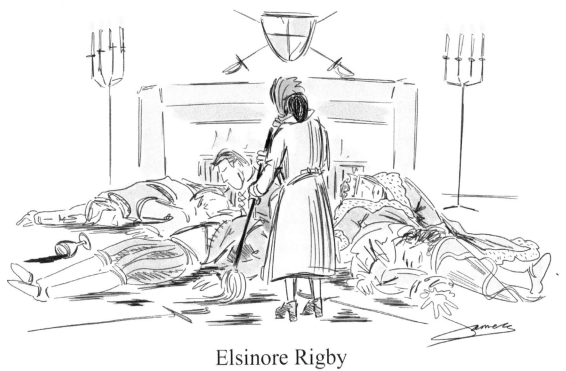

Elsinore Rigby
Mops up the blood in a hall where an ending has been.

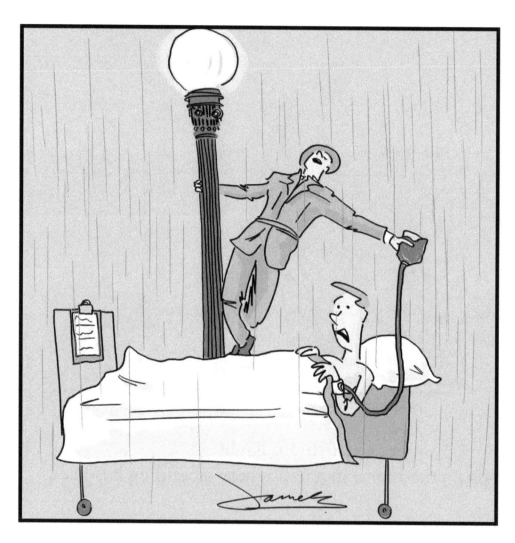

"Are you sure this is Gene Therapy?"

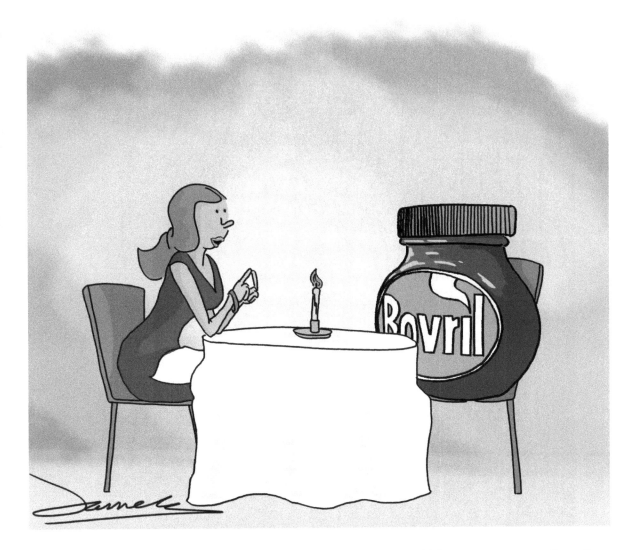

Your profile said you were 'like marmite'

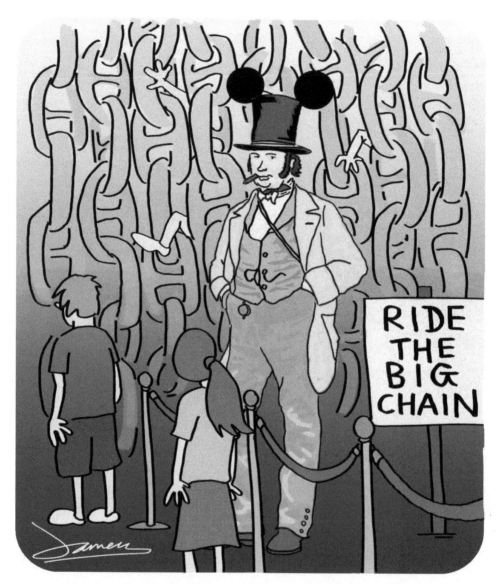

Isambard Magic Kingdom Brunel

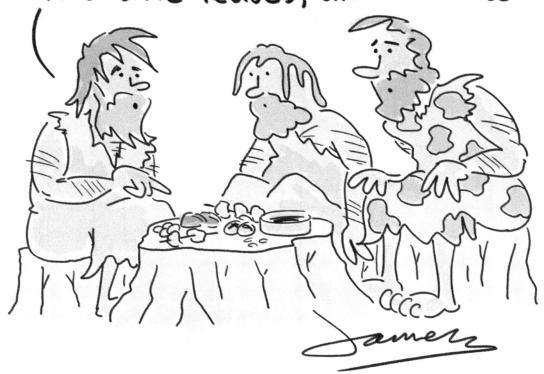

The Mezelithic Era

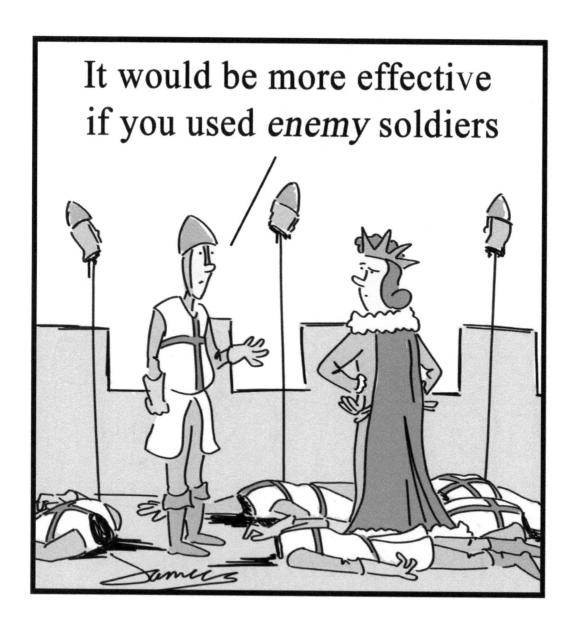

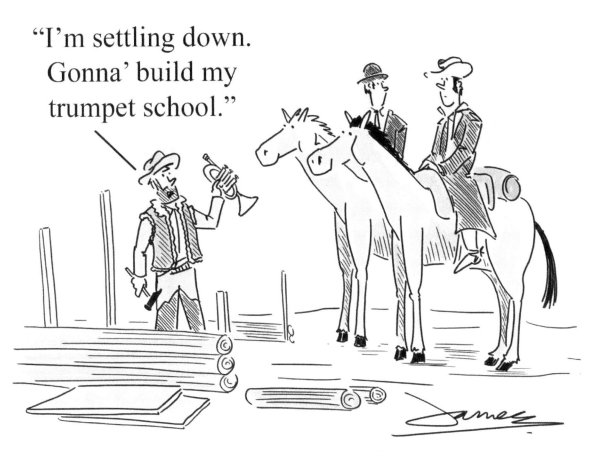

Rooting, tooting cowboy.

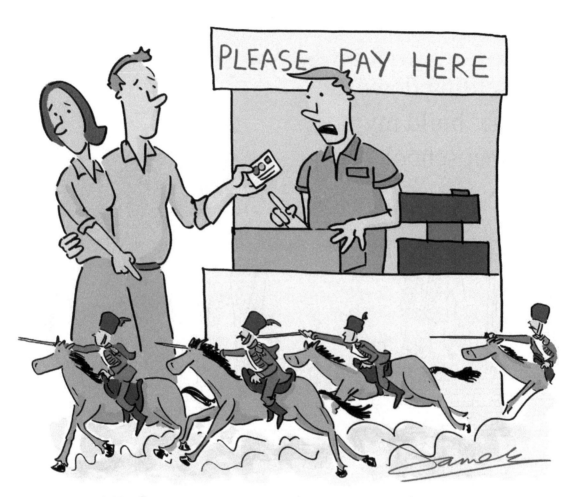

"If you pay by credit card
there will be a small charge"

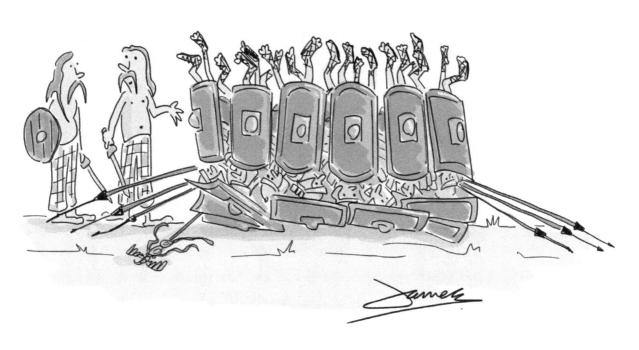

"If you put one on its back it can't right itself"

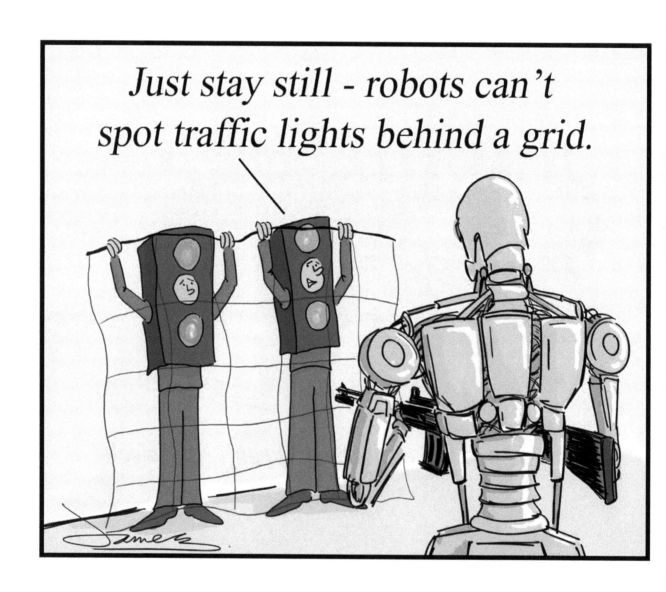

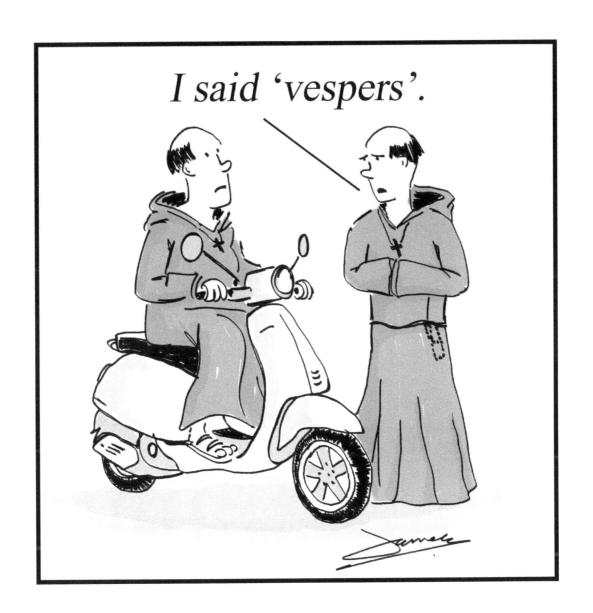

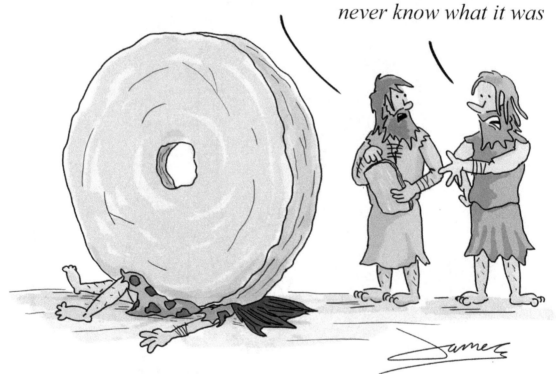

Vaccine

Vaccine! The key to unlocking, the magic bullet, the route out of the madness. Unfortunately for everyone, one of humanity's most amazing scientific and medical accomplishments seems to have also unlocked the next layer of madness. Quite what Bill Gates hopes to achieve by filling the arms of care home residents with tracking microchips is beyond me, though.

Thinking that a virus could be spread by the 5G network seems quite ridiculous, but then humans have always believed ridiculous things. Conspiracy theories make people feel clever and help them to absolve themselves of responsibility or blame. Ridiculousness also seems to peak with social upheaval – see the 'dancing plague' of the Middle Ages – so perhaps it's not surprising that vaccinating a population isn't as straightforward as you would think.

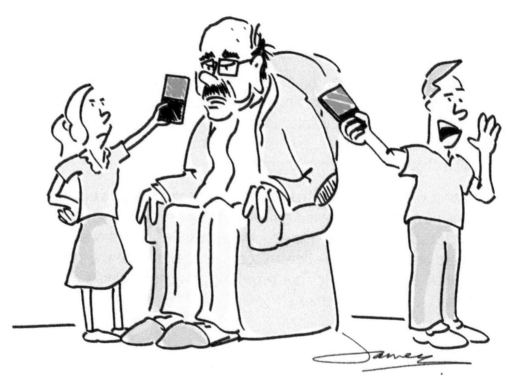

Does Grandad need his second dose
before we can get a phone signal off him

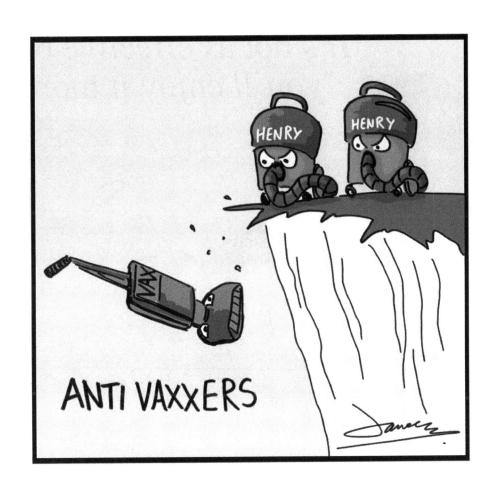

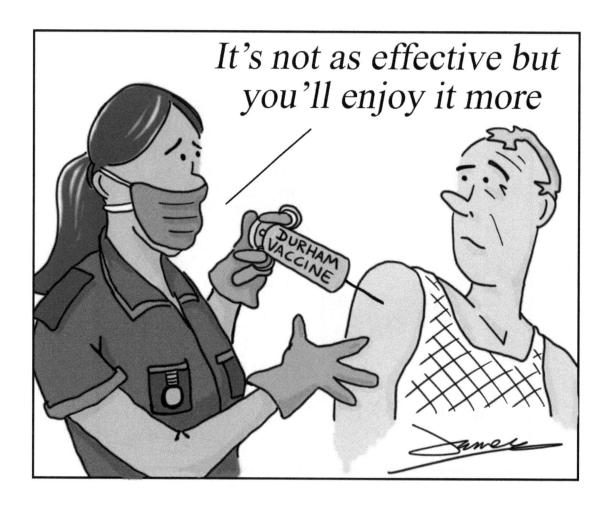

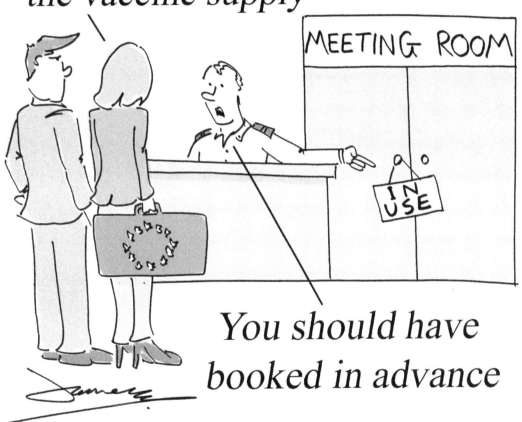

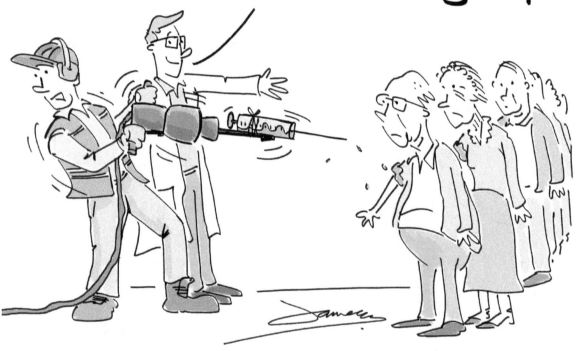

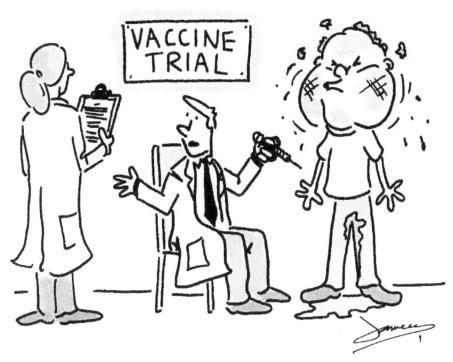

"The question is whether the side effects are any worse than having to carry on working via zoom"

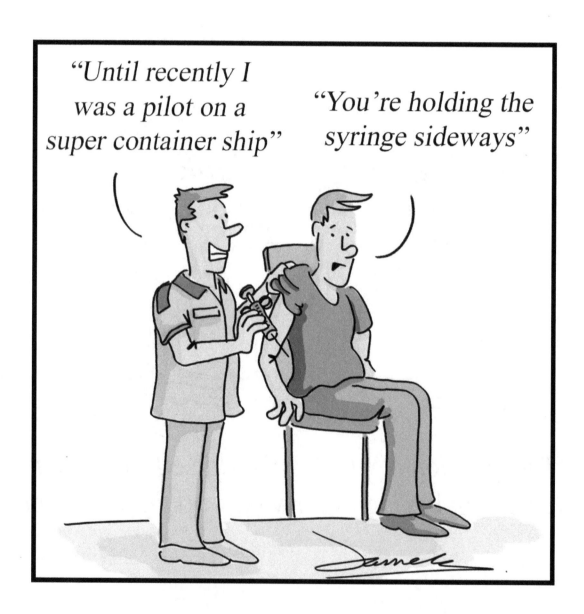

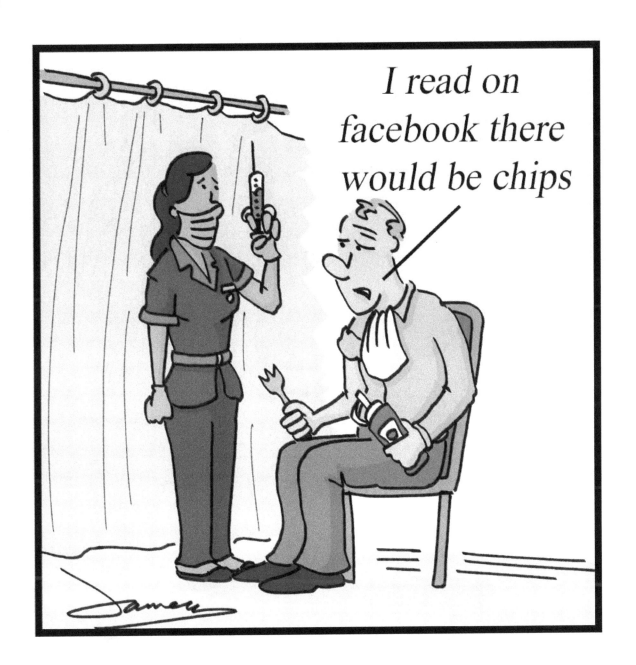

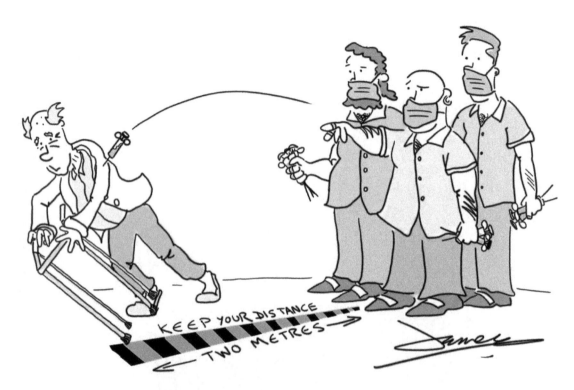

UK darts players step up.

The New Normal

And here we are. Existing in whatever passes for normal. This is how we live now. We roam free, but all the hallmarks of the pandemic remain. We still carry masks, we still meet by zoom, and phones still ping. Perhaps this will become normal. Perhaps it will always seem weird, but at least we know it is just an extra layer of weirdness on top of a very weird little island.

Perhaps everything will pass and in a few years' time we'll start to forget all this. Perhaps people in the future will wonder about this moment. Perhaps your great-grandchildren will ask you 'what was life like during the great plague?". You can wave this book at them. And they'll think you're mad.

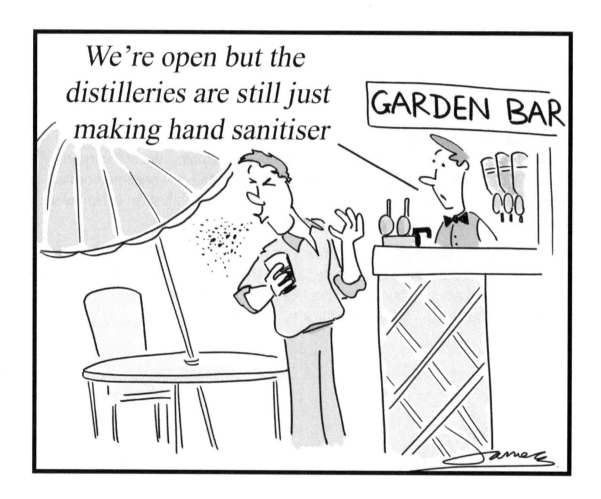

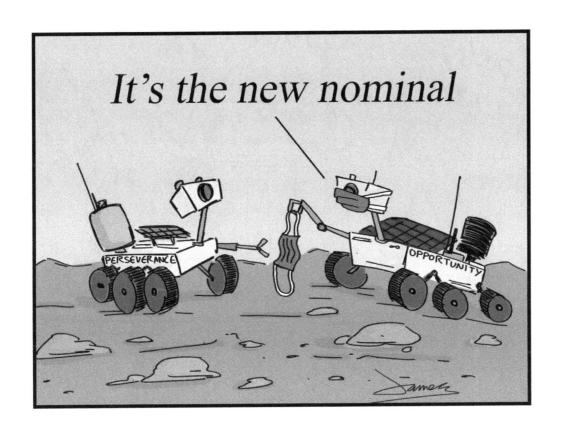

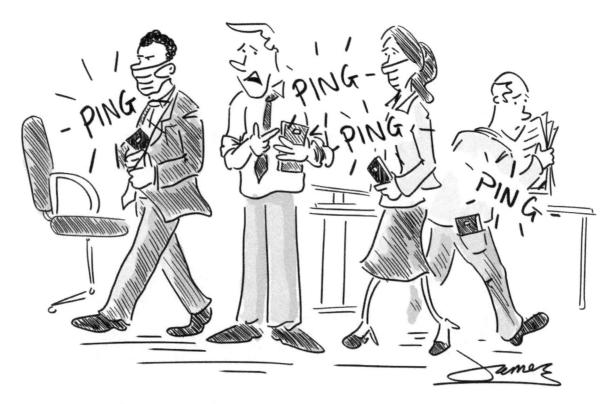

I preferred the app when it didn't work

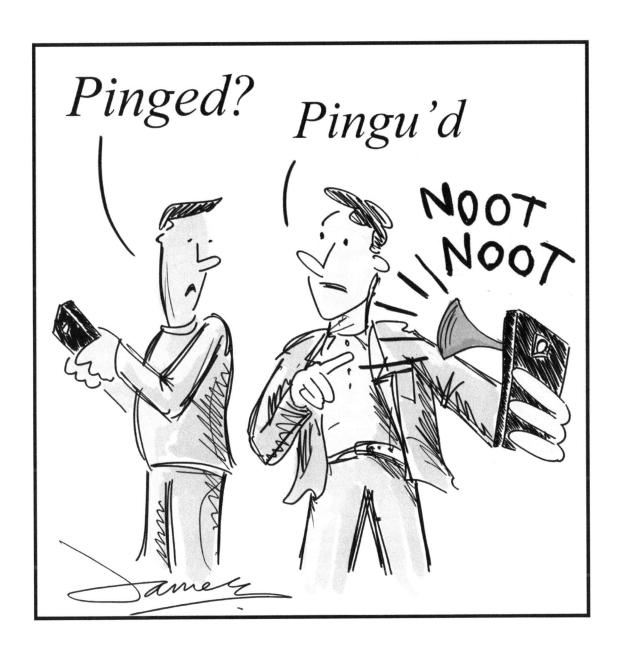

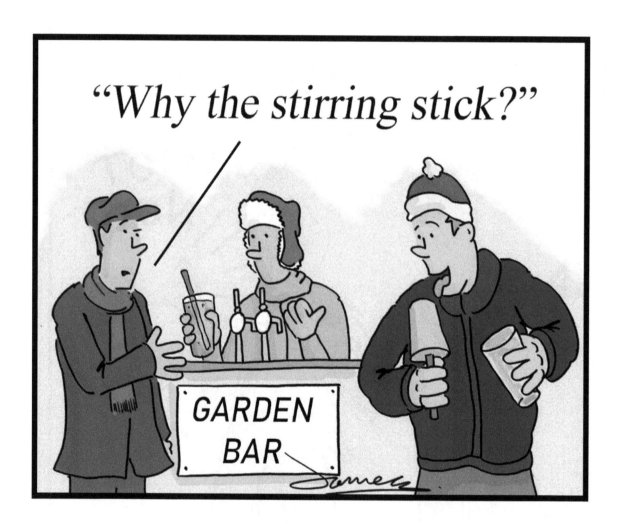

The New Formal

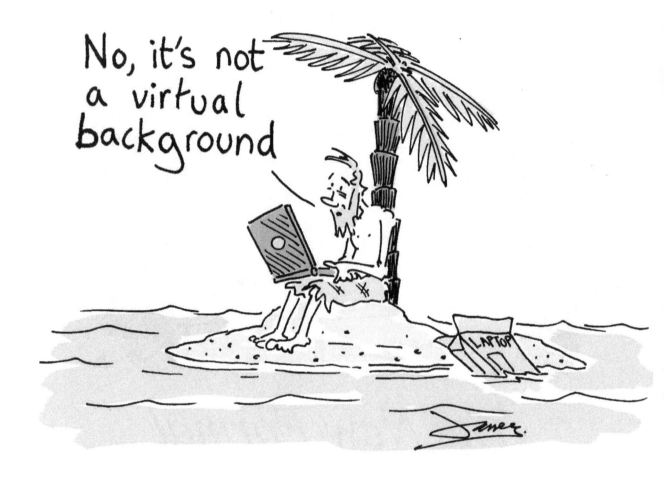

"You're correct – your job *can* be done from home permanently. Jakub will do it from *his* home, in a country with much lower pay"

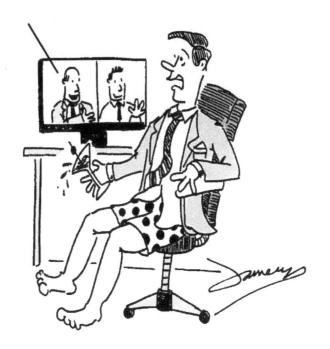

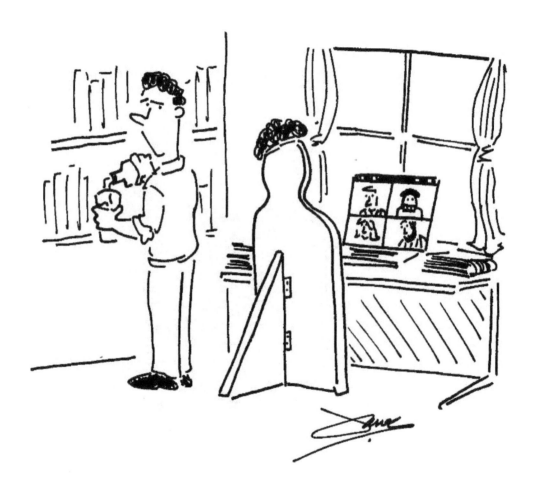

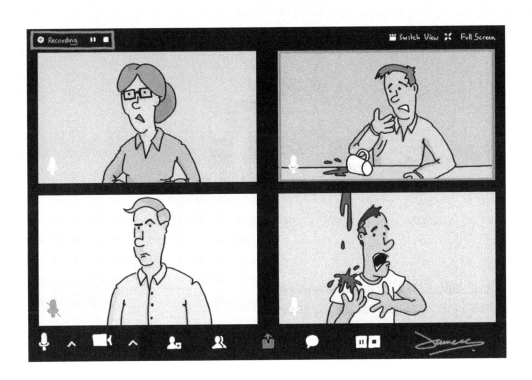

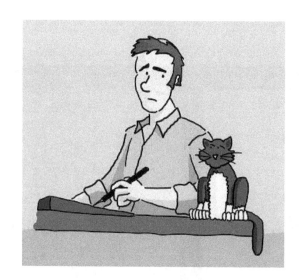

Find out more about James Mellor cartoons and books, and JMC writing and illustration services for businesses at www.jamesmellorcreative.com

Keep up to date with new cartoons by following @jamesdfmellor on twitter, instagram, and facebook.

Thank You!

Lightning Source UK Ltd.
Milton Keynes UK
UKHW051559141121
393950UK00005B/108

9 781913 623791